Generations *of* Women

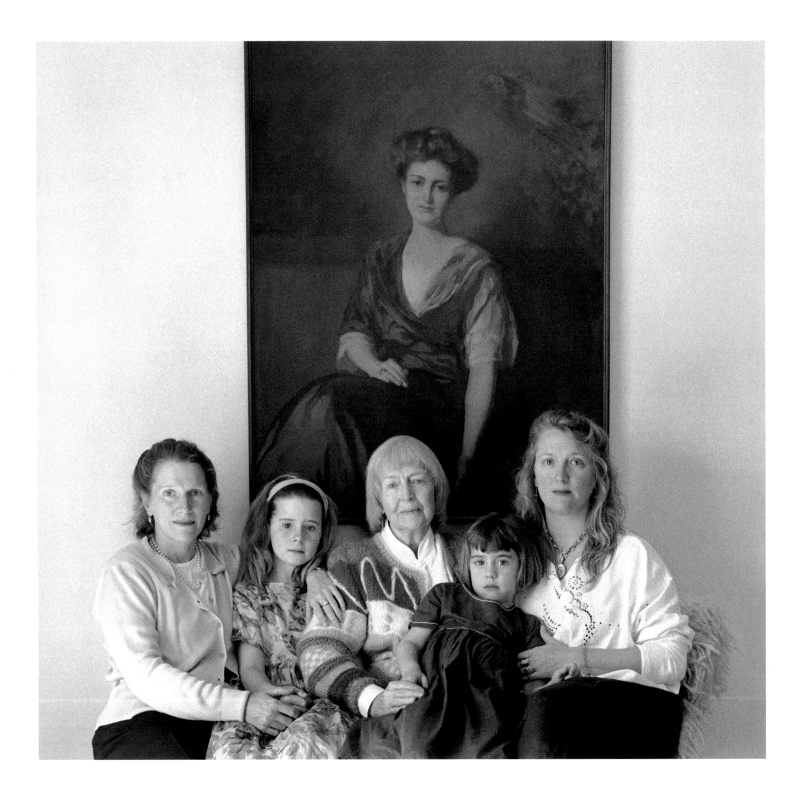

Generations *of* Women

In Their Own Words

Photographs by
Mariana Cook

Introduction by
Jamaica Kincaid

CHRONICLE BOOKS

SAN FRANCISCO

photograph on page 2

Alexandra Truitt, Roseanna Hill,
Anne Truitt, Julia Hill, and Mary Truitt Hill
Washington, D.C. *1997*

Copyright © 1998 by Mariana Cook.
Introduction © 1998 by Jamaica Kincaid.

Library of Congress
Cataloging-in-Publication Data available.

ISBN 0-8118-1907-8

Designed by Jana Anderson, Studio A

Printed by Gardner Lithograph

Printed in the United States of America

Distributed in Canada by
Raincoast Books
8680 Cambie Street
Vancouver, B.C. V6P 6M9

10 9 8 7 6 5 4 3 2 1

Chronicle Books
85 Second Street
San Francisco, CA 94105

Web Site: www.chronbooks.com

For Emily

Contents

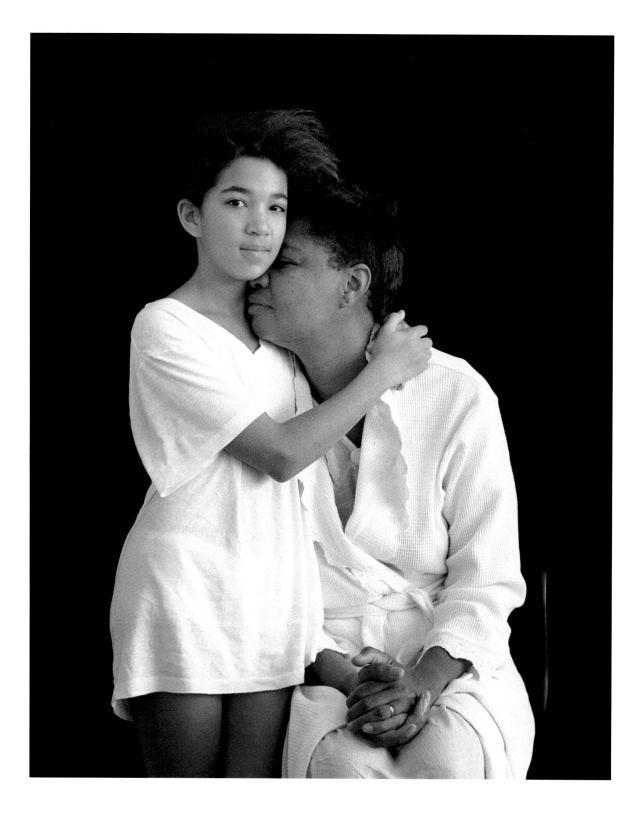

JAMAICA KINCAID AND ANNIE SHAWN
St. Johns, Antigua, West Indies, **1996**

I have a mother and I know her now and she had a mother and she used to know her mother; her mother is now dead. I have a daughter and she has a mother and I am that, her mother. I knew that woman, my mother's mother; I know her more deeply and more fully than if I had spent every day of my childhood life with her. I spent every day of my childhood life with my own mother and I know my own mother better than I will know anyone else. This is so.

My mother's mother was from Dominica. I know this about her, I know she was from Dominica. Who was her mother, I do not know, and I did not wonder who her mother was—that is, who was my grandmother's mother—until just now. That my grandmother could have had a mother was unthinkable to me; to believe such a thing, that my own grandmother could have had a mother also, would have meant that I would have had to think of my grandmother as a child, helpless and vulnerable to the whims of someone more powerful than herself. There could be no one more powerful than my mother's mother; my mother was afraid of her mother, so much so that she could not bear to even live on the same island with her very own mother.

For a long time, nine years (but that is a very long time in a child's mind), I was an only child. I was the only child my mother and father had together; I was the only child descended from my grandmother; her other daughter, my mother's sister, my Aunt Mary, could not have children; her son, my mother's brother, had died. I loved being an only child. I concentrated all my attention on myself, I treasured myself, no hurt directed at me was too small to go unnoticed by me. If I felt lonely that would not have been a small hurt, that would have been a big hurt. I was lonely. I took care of this in a way that even now I find useful. I imagined things.

I was sent to Dominica to visit my grandmother. It was not an ordinary visit, I had been sent to stay with her and my mother's sister because after nine years my mother had given birth to another child, my brother, and when he was a baby and I was nine years old, I dropped him and he landed on his head but I did

Introduction

not mean to do that, I only wished to do that, I did not mean to actually do that. There was a moment when I dropped him on his head and the next moment I was on a boat to Dominica to stay with my grandmother. Dominica is an island far away from the place where I was from, I had never been apart from my mother before, in any case a large body of water had never separated us before. It was on that journey to visit my grandmother, my mother's own mother, that I invented a cousin, a girl named Gillian who lived in Trinidad.

When I saw Dominica for the first time, it was a Sunday morning, and it was raining. I could not have been the first person in the world to see Dominica on a Sunday morning when it was raining. I was on a boat that would bring to my mother letters from her family, it was on that same boat that the reply she made to them was carried back. The *M. V. Rippon* was a substantial thread in the fabric of my little life then, it was the solid thing that moved between my mother, who was a big part of me, and her mother, who was a bigger part of her. I loved my mother then, I did not yet hate her; she hated her mother then, she had loved her own mother a long time ago.

Nothing is ever the same as you think it will be. When I saw Dominica for the first time it was a huge mound of green, a more huge mound of realness than I had ever thought a huge mound could be, and mist, though not fog, for fog is not a tropical phenomenon, no matter what a person who is scientifically familiar with fog might say. I had never seen a landscape like this, not even in literature, for it turned out that a landscape like that had never inspired literature; it had inspired other things, but the written word as I had come to know it was not a part of this scenery.

When I first saw the woman who began the world as I knew it then, my mother's own mother, I was full of sorrow for myself, for more than anything in the world, I missed her daughter, who was my own mother. I could not see my mother in her and so I could not see myself in her; I tried, because my mother would look at various parts of my body—my instep, my second toe longer than my big toe, my hands, the shape of my head, the

slight curve in my back, the long narrow shape of my physical frame then—and would say how much I reminded her of her own mother, how much like her own mother I looked, but when I saw this woman, my mother's mother, I did not think of myself at all. I only missed the person that I was from directly, the person in whose body I had lain curled up, breathing through her lungs, living through her blood. It was seeing my mother's mother for the first time that made me feel pity for my own mother for the first time, but that must have been because I was feeling sorry for my own self, realizing how sad I was to be apart from my mother and so feeling that my mother was sorry to be apart from her mother also. Some time between then and now I used to know with certainty what my own mother thought of her mother; but at this very moment I have no confidence at all in that certainty, the certainty of what my mother feels about her own mother; to recall what I used to know, to put it into words, is not something I am unable to do, it is only that to do it fills me with despair.

My grandmother, for that is what my own mother's mother was, my grandmother, had long ago ceased to like her own life, I knew that then and I can put it into words now, it does not fill me with despair to say that, but she did not want to abandon this, her life. When she was almost still young, she had lost her only son, he died of a disease that is now curable, and from then on she wore only black. My mother when she was almost a really old woman lost her youngest son to a disease for which there is not yet a cure. My mother did not become grief-stricken over this, for by the time it occurred, the course of her own life had been already set, my mother had never let her disappointments or sorrows matter too much to her. I cannot imagine my own life without either of my children now that I have them, and when they were first born I would stand over them when they were asleep and weep and weep at how sad they would be if I were to suddenly die of a disease, curable or not; but that must have been because of the thought when I was a child of not ever seeing my mother again, not for the reason that she migrated to another earthly domain but because I was afraid that she had died while giving birth to her other children or while suffering an attack of one of her terrible headaches. One headache in particular was brought on when to her face I wished her dead because she would not allow me to attend the Mayfair and see some girls who were much older than me dance around the Maypole. I loved those girls.

Where did my mother's mother come from? Who was her mother? Did she miss her, her own mother? In that house in Dominica my own mother's mother and I slept in the same bed. In that bed I clung to her and she clung to me. She did not bathe very often and the smells from her not very often washed body were an overwhelming stink that would cause me to fall into a deep sleep, and in my sleep I almost always dreamed of my own mother. In my dreams my own mother smelled of roses, and this was odd for I was not so familiar with roses that the smell of them was readily available to me.

To sleep with my grandmother, to walk alongside her or a little behind her, to sit with her, to stand still with her, just to be near her in any position at all did not seem strange to me. Her presence was a comfort because I missed the person she most reminded me of, her own daughter; the very sight of her, the very presence of her, was a torment because she so reminded me of the person I missed most in the world, her very own daughter, my mother. And if my mother used to look at me and say that I reminded her of her mother, because of the way my instep was shaped or because of the way my hands were shaped, my grandmother did not ever look at me and say that I reminded her of her own daughter. I loved my grandmother then, she is a mystery to me now. She has been dead for a long time.

The light in Dominica was so different from what I had been used to; it was never harsh, it was never unsparing in its brightness, I could not see every thing. Each morning, no matter the name of the day, she would wake me up just after she awoke herself, and it was at that time of the morning when the day was fresh, when the day was just being born. She dressed herself quickly; she wore white drawers made of coarse cotton and a black dress made

from a finer cotton, but not so fine a cotton that a Sunday dress or a church dress could be made from it. Her only son had been dead for many years then, but she still wore a black as if she would never be free of mourning. From the time she woke me up, I then would do everything she had done, only I was three breaths behind; that is, she awoke three breaths before me, I got out of our bed three breaths after her, I followed her out through the small rooms of her house, she unbarred the door, and we were outside in the cool air. The air was always cool, and inside the coolness were small drops of moisture, the moisture stung our cheeks but not in a way to suggest discomfort, only in a way to suggest that even in such a small thing, drops of moisture trapped inside some cool air, a myriad of sensations could exist, such a myriad that merely contemplating just them, I am temporarily incapacitated.

She would then retrieve an old earthenware jar from which she would remove some cured coffee beans and then she would roast them, pound them in a mortar. And when the beans were reduced to a state of coarse powder they were boiled, separated from the water with a coarse piece of cloth used as a strainer; the water now transformed into the beverage of coffee, a thick, black strange medicinelike potion, was then poured into tiny enamel cups that were decorated with a flora to which we had no intimate connection or even mild acquaintance (had never even seen it in a book, for instance). We drank the coffee stooped over the fire that had just boiled the water that made the coffee, a fire that had been made from wood she and I had brought from a place in the mountains, a place far away, and we had brought this wood strapped to the back of donkey. I then was indifferent to the feelings of the donkeys, but I am not indifferent now; to contemplate their lot now is useless, but I do it all the same, for even what is useless I have come to see is useful.

The taste of the coffee then was new to me, it was a taste I had not even imagined; the taste of coffee crossed the border of my likes and dislikes. When drinking coffee my grandmother and I would lean into each other. This is not something I am now imagining, this something I am now remembering. As I leaned into her I could smell all the old smells that I had become so familiar with from the night of sleeping next to her, and then the new one of the coffee as it clung to the moist fissures that made up the landscape that was the inside of her mouth; some of the teeth in the back of her mouth were missing, some of the others had holes in them, two teeth in the front bottom row were jammed tightly together and this made them slightly askew, as if the person putting them in had grown tired just at this point, as if the foundation on which they stood had grown weak just at this point. This very flaw in the arrangement of my grandmother's teeth appears in the arrangement of my mother's teeth and it appears in the arrangement of my own teeth. It does not appear in the arrangement of my daughter's teeth.

The presence of my mother's mother reminded me of my own mother's absence, and all the more I wanted to be with my mother again. My mother spoke of her mother constantly, her mother never spoke of her at all; I now speak of my mother constantly, from what I am told, by my mother's other children, my mother never speaks of me at all; I bear my daughter in mind all the time, it would sadden me if she thought of me or spoke of me constantly. My past and my future are undimmed as I purposely place the delicate wick that is life, my life, between the two flames.

"What to say?" These words, what to say, would rush out of the mouth of my own mother and her mother when they were at an age, as old as I am now, to take in that every thing, every event, every place, could evoke ten thousand different sensations, ten thousand different feelings, and each of them in deep contradiction, a contradiction that mere acts of violence could not resolve; the contradictions were as old as they were, the contradictions were as old as I am now.

Jamaica Kincaid
Massachusetts, 1996

Lois Behlen
Grandmother housewife
76

My mother was always awfully good to me and did a lot for me, but I never had the closeness with her I would have liked. My dad was on the railroad, but the work wasn't steady. My mother worked to keep things going for us, so she didn't have much time to spend with each of us children. During the Depression she sold newspaper subscriptions to farmers in Nebraska. Even radio wasn't common, and the only way the farmers knew anything about the outside world was from a newspaper, so they wanted their paper no matter what. Sometimes she would bring home live chickens because the farmers wouldn't have money to pay for the subscriptions. And sometimes a farmer would butcher some beef and she'd bring home canned beef.

Donna was born to my husband and his first wife, who died in childbirth with her. I had two children from my first marriage and my husband arranged to adopt them. We went to court and adopted all three children as both of ours. I had to adopt my own children, that was the procedure. I was so fortunate my life went on as wonderfully as it did—so many people's lives fall apart and never really get back on track again.

Donna Kalkowski
Mother landscape architect
49

My mother Lois is not my biological mother and Stacey is not my biological daughter. We're both adopted, that's something we have in common.

My mother can be a friend in a true way because she's nonjudgmental—it's safe to be me in front of Mom. She is the kind of friend I can call when I feel miserable. There were years when I was absolutely horrible, but as angry as she could be with me, that had nothing to do with the fact that she continued to love me. In carrying on to raise children myself, that is something I hope I got through to them. Mom is also a lot of fun. She's not too old to tell jokes in front of, and she's not stodgy. And yet she has very strong, definite beliefs and moral values that I would like to pass on to my kids.

It seems like heredity—Stacey was almost as horrid as a teenager as I was. There were mornings I wanted to give up on the whole job of being a parent. And then we got through it and are best friends, like Mother and myself. I wanted to raise my children to be as independent as I am, and a child can't be independent and dynamic at eighteen if she's submissive, seen and not heard, at seventeen. Unfortunately, that means when they're sixteen and seventeen, you have these dynamic people in front of you who are what we usually call obnoxious.

I don't think the fact that both Stacey and I were adopted played a role for either of us. Mother did such a job on the idea of adoption that I never thought about the fact that she was my stepmother. She was Mom. She was always Mom. Stacey was my daughter. She was always my daughter. People used to come up and tell us how much we looked alike, how much we acted alike. We'd laugh.

Stacey Kalkowski
Daughter assistant director for TV & film
27

I don't want to have children. I don't think the world is any place to bring children into right now. I'm not a super positive person about the world today—more realistic, I would say. I think it would be interesting to be pregnant, but not to be a mother. Most women have the desire to be pregnant at least once in their life, just to experience it. I don't know if I would be a good mother. I don't know if I'd have the patience or if the world would treat my children well, and if I saw them treated badly, that would break my heart.

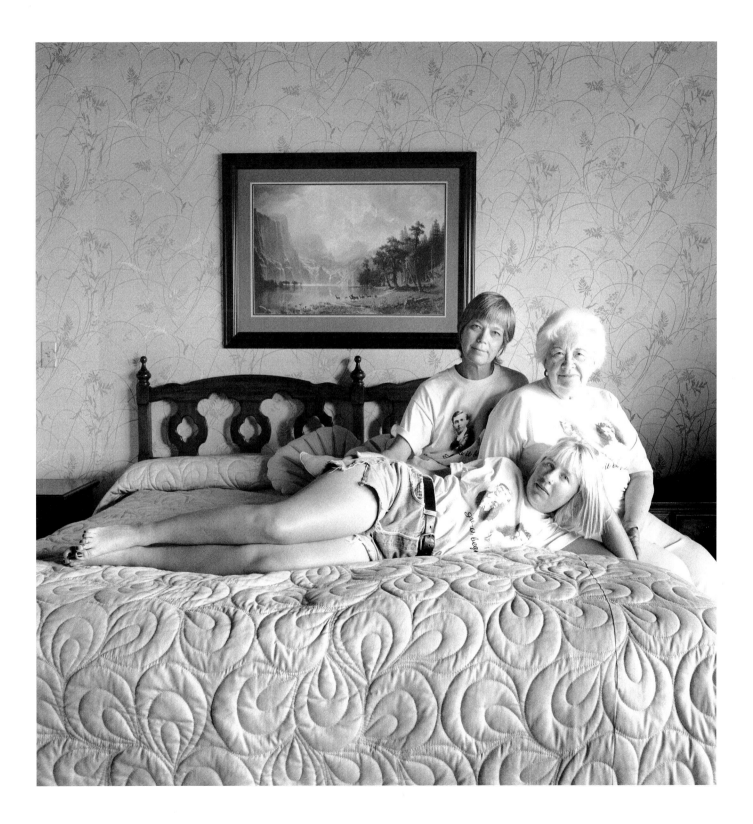

Selma Kaye
Grandmother housewife
77

I had a very good relationship with my mother. My parents were the kindest people. My father was in business and my mother always supported him. I was born and brought up in New York and I've lived here all my life.

In the last twenty years of my father's life, my mother didn't leave him for one single second. She was with him constantly. I used to question her after they moved to Florida, asking, "Mom, why don't you sit with the women and play cards and Dad could sit next to you?" And she said, "No, we spend our time together." That's the kind of family I came from.

My daughter Joan and I are very, very close. Sometimes I tell her things that she resents, but we are still extremely close. She lives in Arizona and I speak to her every day. I speak to my granddaughter Jill every day, too. I'm very proud of that because most mothers and daughters are not so close.

Joan Kaye
Mother community activist
54

I learned the importance of family from my mother and I passed it on to my daughters. I have accomplished a lot in my life, starting two businesses, marriage, and being a family therapist. Part of what I am proudest of is my two daughters.

My relationship with my daughters was strong when they were young, and it still is now. My daughters are very different from each other. Jillian was in fashion merchandising and is now teaching preschool in Chicago. I think no matter what we do as mothers, our daughters find things they're not happy with, as we do with our own mothers. Jill jokes all the time that I once made a salad for her with a snail in it. I said, "Aren't you pleased? It's fresh lettuce!"

My mother was a mother who wanted to be there all the time, which to her meant that she was available from the time we got up to the time we went to sleep. But she would put us to bed by six o'clock so she could go out with my father to help their business grow. We were probably the only children who couldn't watch *I Love Lucy*. We kept flashlights under the bed so we could read.

Jillian Beigel
Daughter kindergarten teacher
27

My mother and grandmother and I are all close, and they are very special to me. My mother let me try new things and learn from my own experience. When I was growing up I spent my summers with my grandparents, and that's how I got to be close to them.

I am similar to my mother and grandmother in a lot of ways, but I'm more relaxed. We all like to hang out and just talk to each other. They think I lead too stressful a life, but I like it.

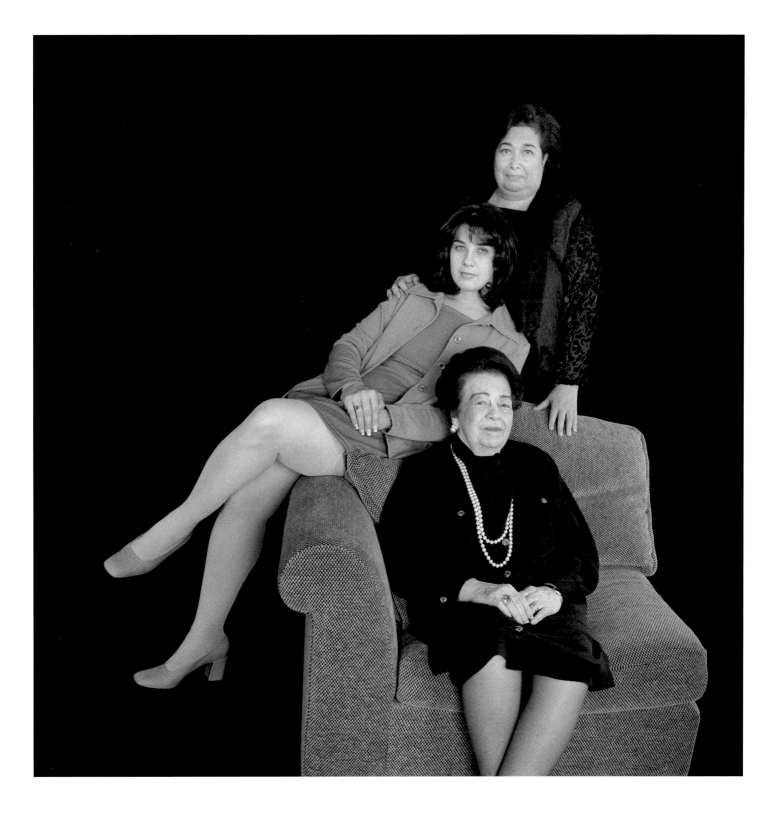

Flora Biddle
Grandmother writer
68

My grandmother, Gertrude Hanover Whitney, was a sculptor. Around the turn of the century she realized that she wanted to fulfill herself beyond being a wife and a mother, and she started sculpting. She had a studio in Greenwich Village, and she realized that American artists at that time were having a very hard time getting recognition and shows and selling their work. So she decided that she would start showing them in her studio. It came to be called the Whitney Studio, and then it became the Whitney Studio Club and members paid five dollars a year. As many members as wanted to could come, and if they couldn't pay five dollars a year they could come anyway. They had wonderful shows and great opening parties for years. She would buy work for her own collection during each show, and finally in the late twenties she realized the collection had gotten so big she couldn't handle it anymore. She tried to give it to the Metropolitan Museum of Art but the Metropolitan Museum was very scornful of American artists of that time and they didn't want any part of it. So in 1931 my grandmother decided to start the Whitney Museum. She died in 1942 and my mother took over as president. I became president in 1975 and worked very hard. I think it's unusual for an institution to have four generations of women who have been interested and involved in it. It's wonderful to be one of them.

I was very close to my mother when I was older because we worked together at the Museum. I also did research for a book on her mother, whom she was very close to. Working on it together also brought us closer.

I was close to my daughter much sooner, and our common interest in art added to it. She was a trustee at the Whitney and then went to work there. I feel very lucky because it's been a wonderful relationship with her for as long as I can remember.

It's extraordinary to be a grandmother, because you feel very close to your grandchildren, but you aren't totally responsible for them. You can enjoy them in a very pure and exciting way and hope that they can talk to you, maybe even confide in you in a different way than one does with one's own parents. Also, it's very special for someone my age to be in close contact with a person of a much younger generation. It's really a wonderful thing to get older and to be confident with young people. It's absolutely vital.

Fiona Donovan
Mother art historian
39

For as long as I can remember my mother and I have been very close. We didn't have to go through any of that adolescent anxiety that so many mothers and daughters have. I constantly hear from people how wonderful my mother is, and it can be hard to have people constantly telling you how wonderful your parents are, but fortunately I've always shared that view, so it's been easy for me. We've always lived near each other and we talk to each other a lot. I had a really special time as the youngest child in a family where my siblings were gone much of the time. So my mother and I have always had a wonderful relationship, and we do everything together. We can look at art and shop for clothes and cook and see family members and friends and go on vacation together. It's very special.

My mother has a general openness about the world. She is very accepting and she just loves people, being around them and helping them and learning about them. She knows how to have fun, which is a big part of life.

My relationship with my daughter, Flora, is intense and extremely close. Fortunately we both like spending time with each other. But it's quite demanding to have a young child who is constantly wanting your attention and you want to be able to give her your best. Flora is very strong willed and she knows what she wants. I think those are basically good qualities as long as she doesn't take them too far. Having a child adopted in China has been very much more special than I could have imagined. I was introduced to a whole new culture that I really knew nothing about, and now when I read anything about China I feel much more attached to this huge part of the world, so for me that has been a very unusual and unexpected part of my relationship with my daughter.

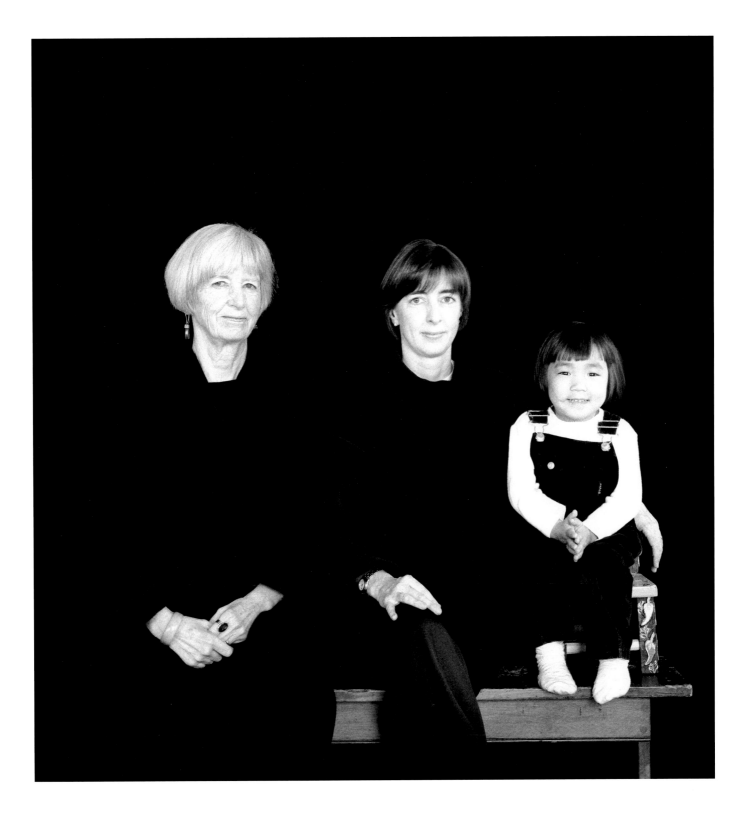

Nicole Chaltiel
Grandmother reader
64

My mother has entered a phase where it is necessary to take over totally for her. It is not easy for her to accept because she must be aware of it, even if it is a diffuse awareness. She has always been very headsrong, made from one piece, never questioning herself. I grew up in a perfect climate of sincerity combined with a solid social and financial position. My father was a physician. He was very charismatic and well known in his profession, one of the leaders of the Jewish community of Tunis. He taught us a lot through his life in a society stratified by various religions and social classes. For me it is a past that is gone but that has left in me a very deep impression which I do not wish to repudiate. I am searching.

What do I wish for Laurence, for Valentine? With the difference of the generations, the change of location, of society, of status, I know that I can do very little for them, a drop of water in this world where so many things have become alien to me. I am illiterate in front of the Internet and the cellular telephone. It is another way and I no longer know if it is good or bad. I hope only to leave them a corner of blue sky in their hearts, a palm tree, and a little bit of the generosity that has so helped me to live.

Laurence Brey
Mother dancer
41

Like my mother, I have a desire to achieve and to be at the origin of new ideas and social ties, but in different areas; my mother in a family environment and I in a professional and artistic one. Can this be explained by evolution of customs, by the fact that women work today, or is it simply due to a difference in our natures?

When I had children myself, I grew closer to my parents and more understanding of the ties that bind us. These bonds supply me with energy vital to my own development, which I try to hand down to my daughter.

We are all individuals, but I think we resemble my grandmother, taken aback by the tiniest crumb lingering on a table that has been cleared. Valentine is only seven, but she reveals prematurely all the traits of a great hunter of crumbs!

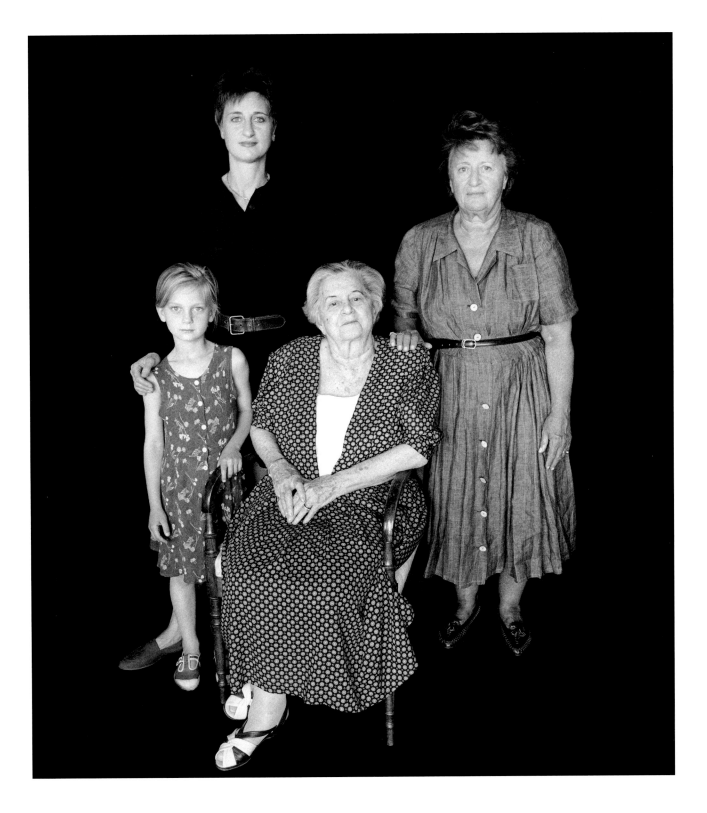

Annie Drew
Grandmother housewife
77

I was raised by my father in Dominica. If I had been raised by my mother, I wouldn't be so rough, but I wouldn't have been able to storm through life; no work was too hard for me.

Growing up, Jamaica had me close to her, I would do everything and she would get the time to read. I don't know if she can still play music, but I sent her to learn to play. I didn't have anybody to raise me the way I did her, but it is to my own interest now that I'm old, because she's my support. All of us get on nicely. Jamaica looks after us and we love her. Even if sometimes she may say one or two things that are fiction, I'm never vexed. As a writer, what she will write is just fiction.

Jamaica Kincaid
Mother writer
47

I was an only child for a long time and my mother and I were very attached to each other. She read a lot, mostly nonfiction. She taught me to read when I was three and a half, so I could have my own books and would leave her alone to read her books. I remember learning to read as if I'd always known how the words looked in a book.

My mother would make incredibly grand gestures, but there was nothing behind them to sustain them. I remember her sending me to a certain school, but then I had no schoolbooks. I came in first anyway, by borrowing other people's books. She insists she gave me a musical education, but she did not. She sent me to a piano class, but I had no way to practice because we had no piano. I don't mind her stories being amazing, and I don't mind the facts. What I mind is their emotional dishonesty and blindness.

At sixteen I was sent away to America to help support my family. That was the beginning of my adult life. I dutifully sent my paychecks home, and then one day it dawned on me that I was being asked to support someone else's mistake. I hadn't had more children than I should have had; all I had done was be the oldest child. I was a brilliant young girl who should have gone on to a university. Nothing was dependent on the sacrifice of my life. It was willful that somebody just interrupted my life for these people. I stopped sending them money and stopped writing to them and began to send myself to school. I became the parents I didn't have for myself.

At the time Annie was born, I hadn't seen my mother in twenty years. I have powerful feelings of despair, dislike, and even sometimes revulsion toward my mother. I don't know her really, and I don't know if she wanted any of us. She did some incredibly loving and intimate things, and then some things were not acts of love at all. I feel I'm similar to her in some ways—we're both fearful of intimacy—and that's painful.

In the natural order of things my mother will probably die before me, and I think it will be very hard for me to live in a world without her, to construct the world without her presence. I'm so used to starting my life beginning with her and with her mother, whether her mother was the woman I knew or the woman she claims was her mother. What's interesting about her story is that she's made a romance of her life.

Annie Shawn
Daughter
12

My mom and I love each other very much. I'm kind of similar to her, but I'm more forgiving. My grandmother and I have the same name, and when I'm being mean my mom says, "Oh, you're just like Grandma Annie," but I don't think I am. Sometimes my mother acts like my grandmother a little bit. I think my mom's going to look like her mother when she gets old.

My mom's not like any of my friends' mothers, they're all normal, not very interesting. Everyone says my mom's the coolest mom and I agree. At my parties she dances and teaches everyone weird dances.

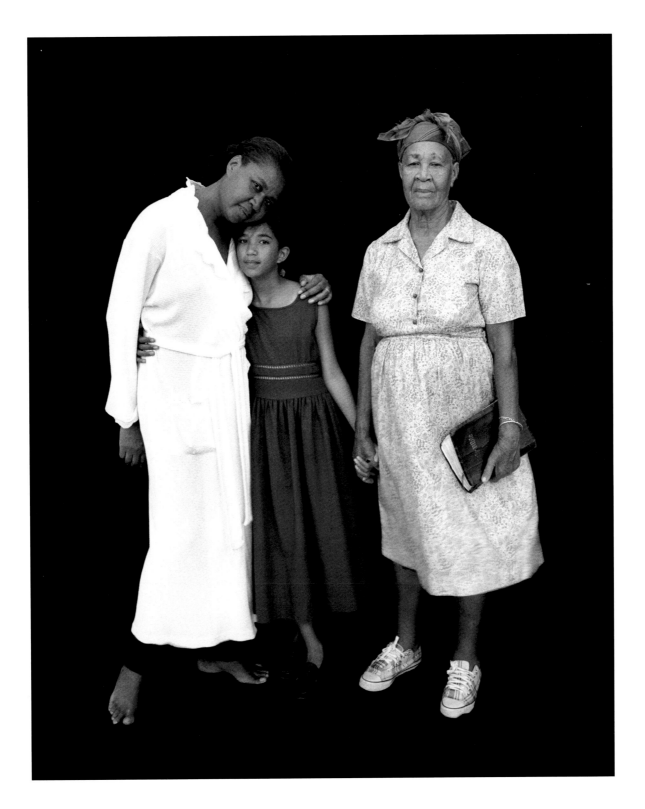

Aicha Elbehiri
Grandmother domestic cleaner
52

Rachida is my first daughter and she is my best friend. We have a very open relationship, thank God for her. I brought her up more like sisters than like mother and daughter. When she was eleven years old and came to live with me, I told her to tell me anything she had in her heart, not to hide anything from me. So we started an open relationship. I did the same, telling her anything that happened to me. Sometimes I had to wake up early in the morning to go to work, but I never told her that, I just waited until she went to sleep and then I went to my bed.

My daughter Rachida's life is a lot like mine. I brought up my children the Moroccan way, not the European way. They never went out, never drank or smoked. Our parents choose husbands for us, and if they tell you to marry a man, you have to marry him whether you like him or not. If you teach your daughter to be nice to her husband, she will learn it from you how you are with your husband and the husband will be happy with her too. And when you have children with him and pass some time with him you start loving each other and that's marriage. Nobody is great when you first get married, but you get used to each other and you stick with him until the last day of your life. That is our Moroccan culture.

I hope my granddaughter, Samira, will grow up like her mom and her aunt, but of course, we never know what is going to happen. If she follows our way, she is going to lead a very good life. I advise her to listen to her mom and not to mix with children outside. If our children mix with too many people they will not stay in our way.

Rachida Chadli
Mother hairdresser
31

My mom and I are very close. She came over to England when I was five and I stayed in Morocco with my grandmother and my auntie until I was eleven. I used to see my mom every year when she came over on holidays, but I missed her very much. She was working, and as soon as she got her flat we came over. When I came to England, I was very close to my mom. I went back to Morocco to be married and I stayed there for three and a half years. Even though I used to come over here and see my mom every year, still I missed her very much. Now I try to make the most of seeing her every day.

My mother is a wonderful woman and she taught me everything, how to bring up a nice respectable family, to be loving to your family, and to give them everything they need.

My daughter, Samira, is six years old and I try to be very loving because I know what it's like not to have your mother when you are that age. I had an arranged marriage, but I wouldn't want my daughter to have an arranged marriage. I would like her to marry somebody she knows and respects. I love my husband and respect him, but I grew to love him in time; it's not the same as choosing your own person. My younger sister chose her own husband and she is very happy.

Samira Chadli
Daughter
6

My mom makes food and things, sometimes she makes hot milk for my baby brother and sometimes she makes it for me. Sometimes I need to help her; sometimes I don't. I do my homework, because my mom tells me to. When I grow up I want to be a doctor because my grandma worked in a hospital.

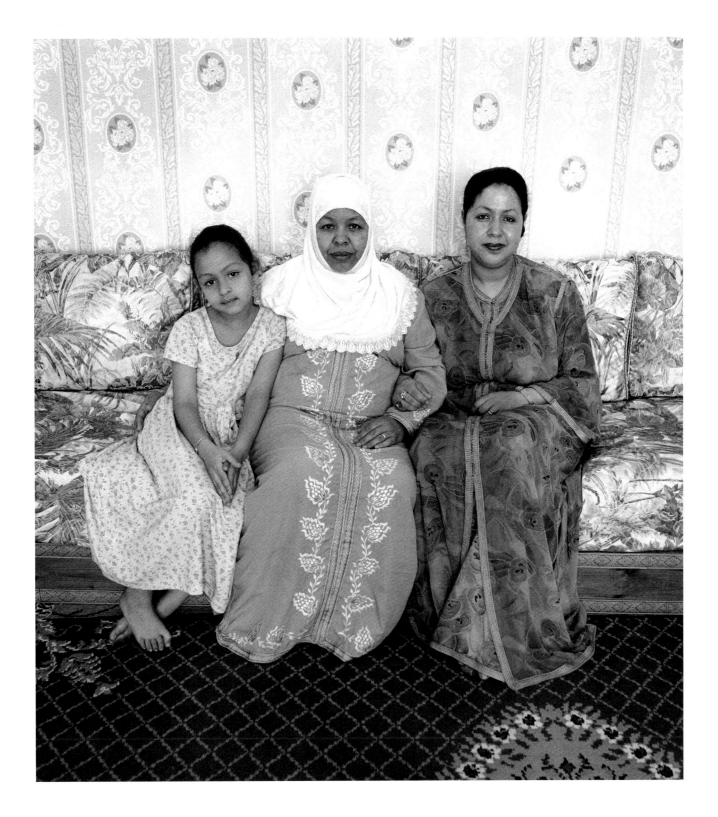

Eileen Gillespie
Grandmother interior designer
65

Gail's three children all have a comfortable way about them; poised, happy and independent-minded. My own upbringing, more restrictive and sheltered, led me to attempt to instill independence in my own children.

Lindsay reminds me of Gail. I hope when she turns thirteen, the bewitching year for younger girls, her mother handles the teenage transition years better than I did when Gail passed through those years herself, though we both made it through, none the worse for wear.

Gail Garcia
Mother housewife
40

My relationship with my daughter is a close one. We are open and honest with each other. I work hard to keep our lines of communication clear. Sometimes I drive her to distraction because she thinks I want to talk about everything and it is obvious she would like some things left unsaid. I try not to impose too much of what I think about things on her. She is definitely her own person and will be able to find her own way easily.

My mother and I didn't talk as much when I was younger as we do now. Our relationship has gotten stronger in recent years, probably since I have had children.

As soon as Lindsay was born, all I wanted to do was apologize for all the trouble and sleepless nights I may have caused my mother when I was younger. It suddenly became crystal clear to me why she had worried about me so much. I've learned to worry from my mother. She's very good at it and I seem to be getting good at it, too. I know Lindsay often sees this similarity between my mother and myself.

Lindsay Garcia
Daughter
12

Sometimes my mother and I go to girl movies. And we'll go shopping together and exchange each other's fashion opinion, even though she hates to shop. My mother is a loving woman and although she has her moods, she is a kind person. She sometimes butts into my personal life too much, but she mostly lets me remain independent. We don't agree on everything, but we are still friends.

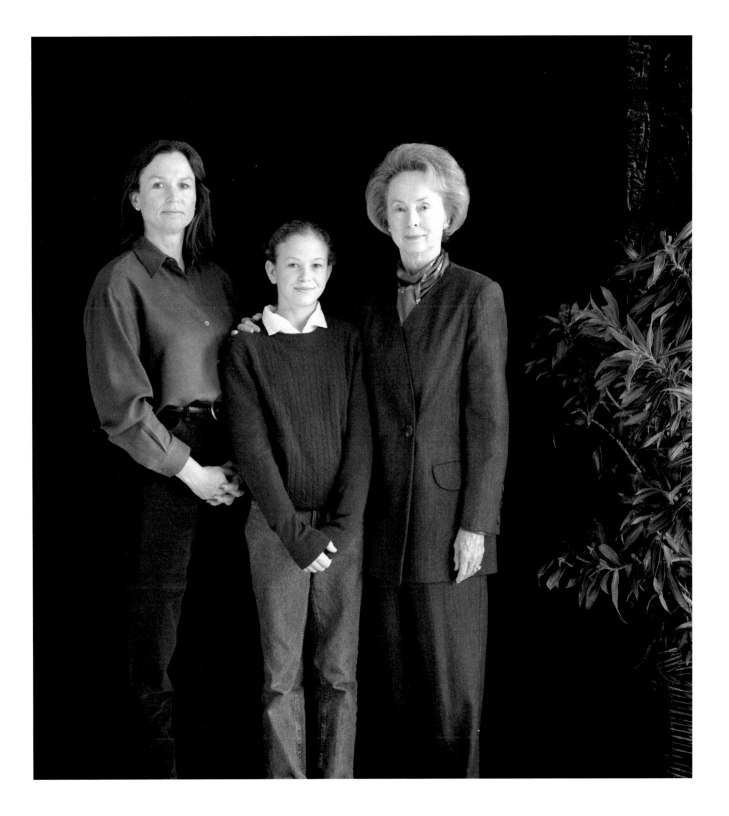

Mae Greenwood Contreras
Great-great-grandmother retired maid
96

I was born in Atlanta, Georgia. My mother was a beautiful woman, deep mulatto. We adored our mother and she adored us. Everything was beautiful to her. The darkest little baby was the one she would pick up and put around her neck. She didn't care how colored they came, they were lovely to her, and she had ten.

Although my mother had a lot of children, we've done the best we could. We didn't look on life and things and sigh and say what a hard time we were having. We didn't consider life like that. Life is real, it's what you make it. We thought life was beautiful, and we were glad to be with each other. We loved people and people loved us because of that.

To me, my daughter-in-law is the most beautiful thing in the world. I think of her like a daughter because she has been one.

Elnora Greenwood
Great-grandmother retired drapery fabricator
80

Mae is my mother-in-law. We've been close for fifty-some years. I'm still in there for her. I have deep feelings for my own mother because she was quite a mother, but she died in Arkansas when I was twelve.

I keep my family close, all of them. I try to stress love in the family, which will keep us all together. They just gave me a surprise party. That was something, the second time in my life I've had a birthday party.

Things have changed from the time I came up. For women in the old days, there were things that we refused to talk about. Now, it's out there. You've got to accept the change in the generations. When I was a kid there were no drugs, there was not a whole lot of stuff that seems to be destroying a lot of civilization today, but we have to live in hopes that it'll get better as time goes on.

Charlotte Smith
Grandmother administrative assistant
53

My mother is a very special lady. She's a strong mother, she's not afraid to tell me when she feels I'm doing something wrong. She is a really giving person, she opens her heart, her home, and her wallet to people. For most of her life my mother worked at home in her own business, so she was always around. I had to work while I was raising my girls, but I got home close to the time they would arrive. My girls and I did a lot of things together. Every place I went, they went.

My daughter Stephanie is a unique individual. We don't see each other so often because of our work situation, but when we do it's like picking up and continuing on. It's like some friends that you have, you don't see them for a long time, but that closeness never leaves you. That's the way it is with Stephanie and me.

Stephanie Barajas
Mother secretary
33

My mom taught us to be independent, to put education first, to pursue our goals. She taught us discipline and responsibility. With my daughter, Vanessa, sometimes I just shake my head and wonder where she's going, and people say she acts a lot like I did. I think she's more headstrong than I was, she's very independent and she speaks her mind. She'll be all right; that's going to be a girl who can take care of herself.

My grandmother Elnora helped raise me, she's like my first mother. Grandma's always kind of spoiled us; her children, their children, and even her great-grandchildren. She's watched and babysat for us all. She's tender, loving, caring, a woman with a lot of wisdom and she shares a lot of that wisdom with us.

Vanessa Barajas
Daughter
6

My mom is nice to me. She spanks me sometimes. She sets out my clothes and stuff. I play with her and go to Magic Mountain with her and go do errands with her. I help her clean up and I help her do her hair and I help her do her back and zipper. When I grow up I want to be a doctor. I have to because that's what the mail said. I opened it and it said, "When Vanessa grows up, she's going to be a doctor."

26

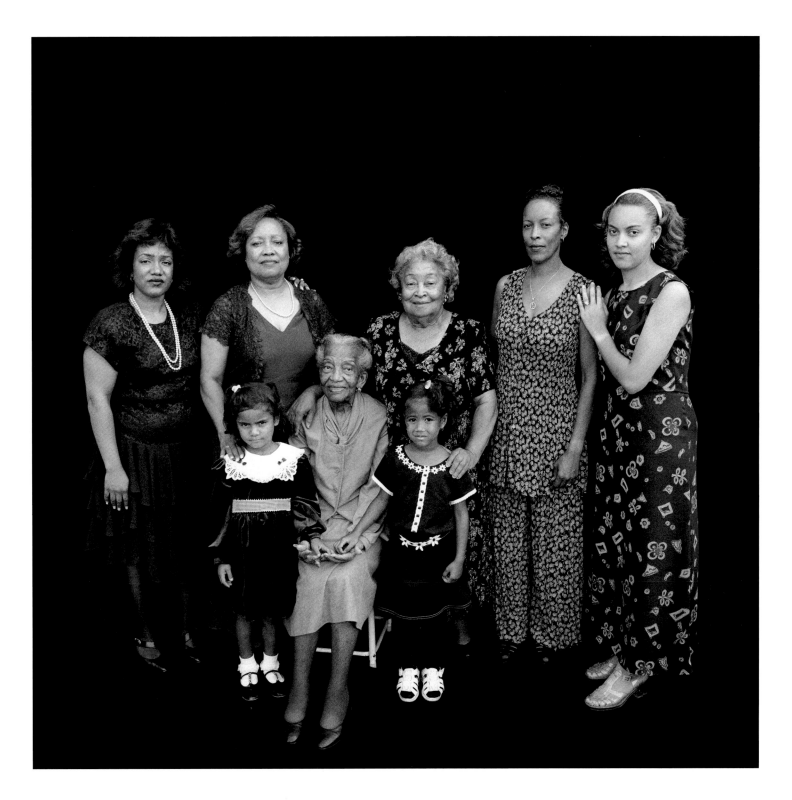

Marie Haselton
Great-great-grandmother retired store owner
83

Barbara has been a wonderful daughter and takes care of me. We talk every day. When she was growing up, I taught her to be honest. Her life has been similar to mine. We both lost our husbands, but she was lucky enough to remarry. The best thing about being a woman has been raising my family. I love my new great-great grandchild, she's a dear little child. It's been a good family life. You always have to lose someone and of course that takes away from life but it's worked out very nicely because we have each other.

Barbara Davis
Great-grandmother housewife
65

What I like best about being a woman is being with my children, and the hardest thing about being a woman is worrying about the children. A woman has to be strong all the time. There isn't a time when you don't have to be strong because there's always something going on in your life. There's been a lot of tragedy in our life, but we've been able to hold on to each other through it and I think that's important.

Tamara Teel
Grandmother leasing agent
41

My daughter Frankie is a very loving person. Where partnerships are concerned, she's following my track record, which wasn't good. It took me a long time to realize what a partner should be and I'm trying to teach that to her now, hoping she doesn't have to go through what I did in order to get where I am today.

A woman should be strong and have her say in life. She's not something you throw back in a corner. I hope I can instill that into Frankie.

No matter what you do in life, if you've made a mistake and you've learned, it's a learning lesson; it's not a mistake. You keep going forward; just don't go back. I had a drug problem years ago. I sat my kids down and I said, "I have a drug problem. I can't afford a rehab so we're going to do this together." And we did. We went through it together. We all came out with shining colors and we were great.

Frankie Hailer
Mother nail technician
22

I've always wanted to have a baby. If I could have, I would have had one at eighteen. I think that's because my mom and I are so close and she had me when she was nineteen. I think our relationship is special because of that. She did a lot of growing with me and I wanted the same relationship with my child. I'm glad I had a girl.

My grandmother is more like a mother to me and my mother is more like a big sister and a best friend. My grandmother still thinks I'm eight years old. I feel very protected and cared for. I know I will always have my family and I want Taylor to know that, too. It's always been like that and I know it will still go on that way when I'm a grandmother or great-grandmother. Family is something you're going to have around forever, unlike boyfriends and friends.

I want Taylor to have the closeness to me that I have with my mom, but I want her to have more than I had. I never got to have a letterman jacket or a class ring or my senior trip. Those things are special and I want her to have them. That's why I'm only having one child, so I can give those things to her. I don't know what my mom did to make me strong, but I hope I do it to Taylor. I'm a nail technician and I love what I do. It's what I've wanted to do since I was in the eighth grade. I hope Taylor will find an interest in something too. That way she'll enjoy her job and it will be a career for her.

A woman can do anything she wants to do. A man has to do the macho thing. He has to do the hunting and the fishing and the masculine things, but a woman can go either way. I enjoy hunting every season. I've always been a tomboy. I like fishing. I played softball, football and ran track. That's what's great about being a woman. You can do anything you want.

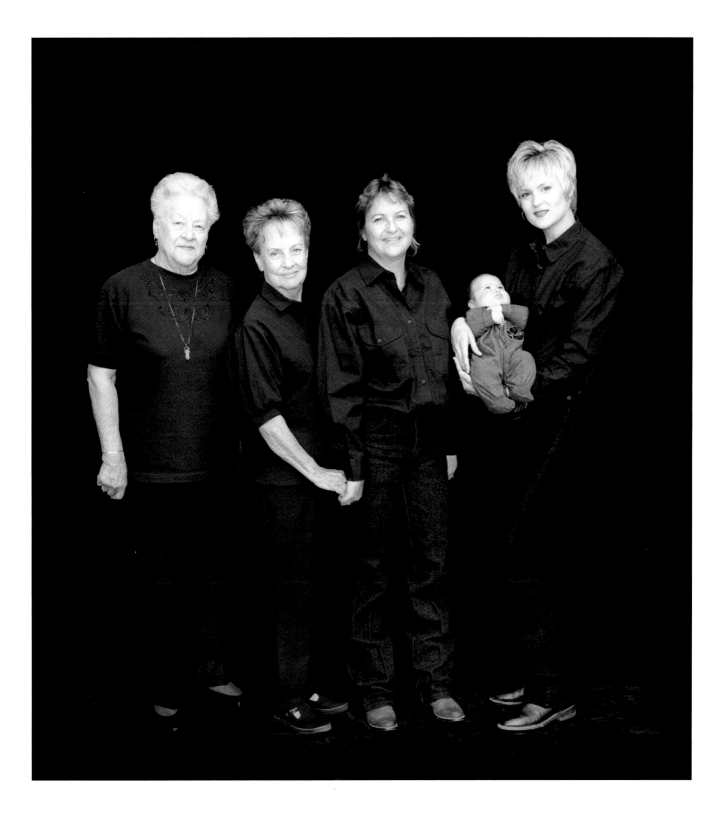

Daphne Hellman
Grandmother harpist
81

I adored my mother when I was small, and then when I got to be eight or nine, she became censorious, reproving, critical, and I had an angry relationship with her that lasted a lot of my life. My sister Bibi and I each had separate governesses, severe and isolating. Bibi seemed like the good one. I was the bad one. We snuggled in the dark and told each other stories.

Life with my mother was not warm till she was in her eighties. She came to my house once and criticized some dust on a table. I said, "Mummy, why do you always make me feel bad when you look around my house?" "Oh, darling, I'm so sorry. I won't do it again!" But the next time it was the same thing. I cried when I read her poems after she died.

Her poems were very moving. They were good poems. I felt I'd been ignorant of her sensitivity.

Daisy, my second child and only daughter, was frisky and energetic. One time she painted a mustache on her grandfather's portrait and we blamed her brother Benjy. She has beautiful green eyes. She is sociable and generous, and a fine sitar player. I depend on her for commonsense guidance.

My granddaughter Sasha looks like a wild, wonderful Barbie doll. She gets along with Daisy's parrots, who are picky about their human friends. Sasha is observant, hip. She draws well, writes well, too. I love her.

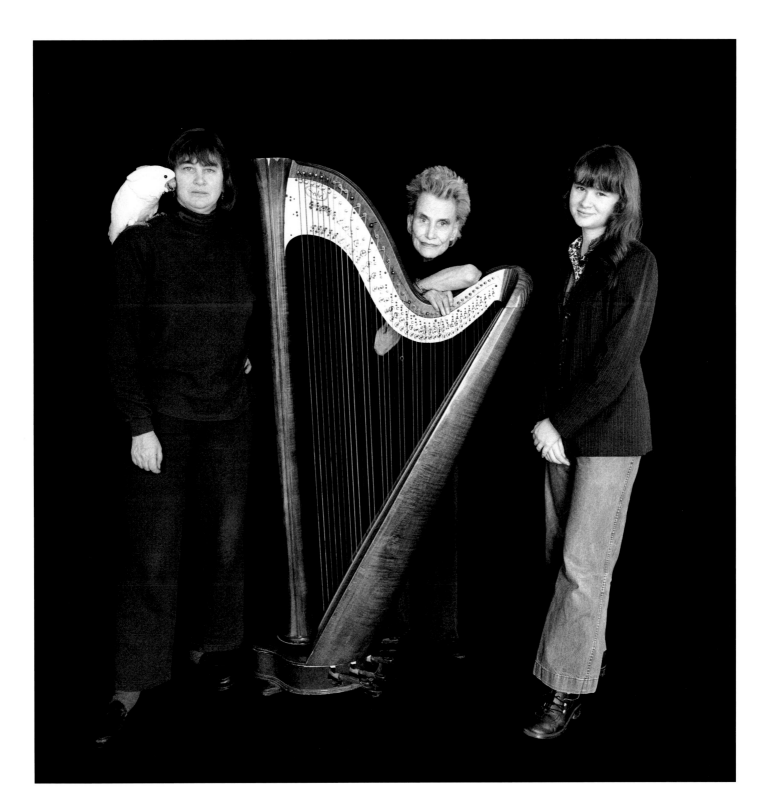

Aurora Huston

Mother photo stylist and artist
48

My relationship with my mother has been a little difficult because we're so far apart in worlds. She comes from the Philippines, a completely different culture, a different world. I always thought she was very brave to come to a country where everything's so strange. We have always struggled to understand each other. My mother's gone through a world war and she's lost two children, and I think it takes tremendous courage to keep as happy and as stable as she is. She's always made an effort to talk to us about her experiences in the war so we would know our history. She knew that in coming to the United States some of that culture would be lost. She was always hoping that we would remember the land we came from.

Having come to America, I'm stuck between two worlds and I really don't belong in one or the other. I have to really work to understand my mother, but at the same time, my daughter is also in a completely different world. I can be very frustrated with both my mother and my daughter until I stop and think. Unless I put myself in their place, I can lose sight of their struggles and how they see things, especially my mother.

When I was a teenager my mother, coming from Filipino culture, sheltered us for a long time. I didn't start dating until I was nineteen and moved out of the house. Sex was such a shock for me. Nobody ever told me anything.

Nowadays you have to work so hard to keep your children from losing their innocence early. I did the same thing to Amanda my mother did to me, protect her too much instead of informing her of everything that could happen. With Amanda, everything was thrown at her at one time; it was almost like a dare to be familiar with the opposite sex at an early age. Amanda and I had a hard time, but I think there are no other mother and daughter who can love each other as much as we do, because we went through fire and brimstone together. Amanda had her wild times and I felt very guilty about that because the whole time I was trying to calm her down, I knew what I was like at her age and I was maybe ten times worse.

When we look at each other now, we know those times and we grieve about them and we probably both will go to our graves regretting the harsh words and all the hard times we had. But I think it's brought us to a very wonderful state because she understands me much better than she would have if we had had smooth sailing all the way through. She knows the good and the bad about me and I definitely know the good and bad about her. We're not hiding anything from each other anymore. It's not like she's trying to be the perfect daughter and she knows I'm not the perfect mother. I've always told her, God never came to us and gave us instructions on raising children.

I had Amanda at a very early age and because I was so sheltered, I had no idea how to be a mother or what it took to raise a child. It was the most frightening thing. When I had to take her home from the hospital, I cried and I begged them to keep her longer. I thought, Just keep her two more weeks until I can go to the library and figure this thing out. We're never given that time.

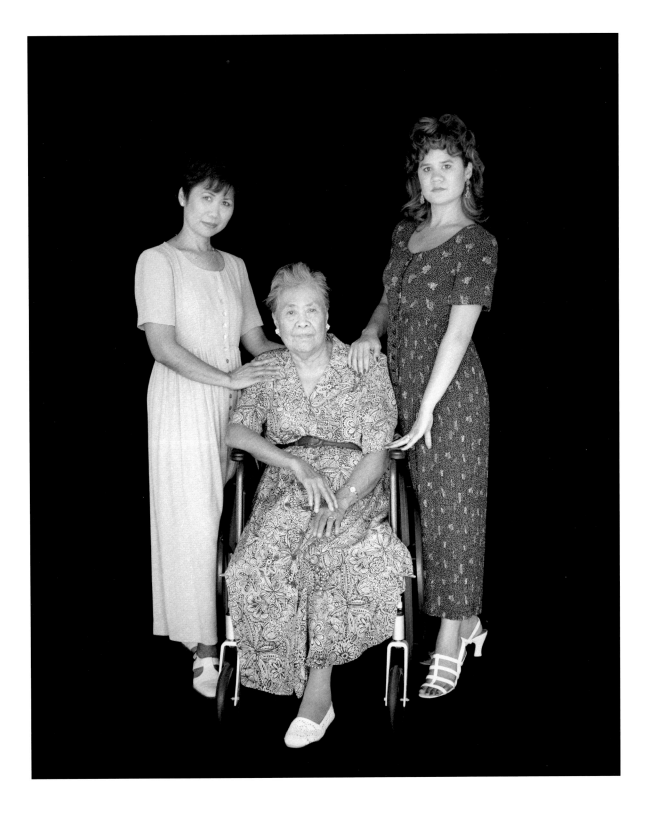

Marie-Thérèse Jammes
Grandmother historian & collector of photographs
68

In looking at this portrait of our three generations, I cannot forget those who preceded us. My grandmother, who lived for almost a century, became blind in the last years of her life. She spoke to me of her life and she confided in me until her last days. My mother was an energetic and authoritative woman, very kind-hearted, and in spite of our different natures we always understood each other so well. I also accompanied her into her old age and I became her protector.

With my daughter, Isabelle, I rediscovered gentleness, refinement, a marvelous shared understanding. As to Flora, my granddaughter, her quick-wittedness, her energy, her will make me think often of my mother who had a deep attachment to her.

Isabelle Jammes
Mother rare book dealer
43

I have a serene relationship with my mother, made up of an immense affection and respect that grows with the passing years. The turbulence of my adolescence is far away now. It is my turn to be a mother and to know the joy of having a daughter.

When I saw the photograph, I discovered the statue for the first time. To me, it symbolizes my mother's purity, richness of heart, and immense human qualities.

During the pose, I felt the absence of my grandmother, Jeanne. She would have loved to be there with us. She would have worn a hat and she would have clasped her great-granddaughter Flora in her arms. They recognized each other, their passionate and generous natures connecting the generations.

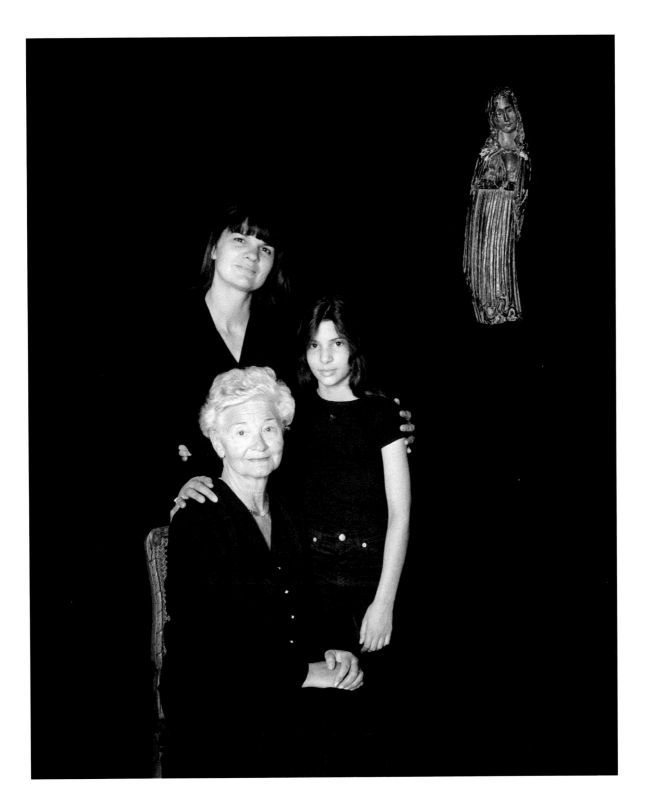

Ruth Jordan
Grandmother social worker
75

My relationship with my daughters is much different from the relationship I had with my mother because my mother didn't speak English. She spoke Yiddish and I had to interpret for her. She was handicapped in her left arm and she limped as she walked. My father had a store. My mother would sit by the door cleaning vegetables or picking out the onions and the potatoes that weren't good, and I worked in the store from the time I could look over the counter. On Friday nights we would play dominoes, crack nuts, and eat oranges since we couldn't do any-thing after sundown because we were Jewish.

I'm a converted Christian. I was baptized and I joined the Baptist Church and I wouldn't go back. I love hell-fire preachers and I get very emotional.

My relationships with my daughters are altogether different from the relationship I had with my mother. They're very close to me and to each other. If one is having problems, we all have the problem and telephone bills go sky high.

Helen Richter
Mother nurse practitioner
45

Now that my mother and I are adults we get along well, but I had a rocky adolescence. I was a sixties kid and was rebellious. I felt like my mother didn't understand me. Now, I think she trusts me and when it comes to things like her health and her well-being, I'm the one she usually consults.

I love my bird, Jade. She's my heart. Sometimes I'm overprotective of her because I know she has a hard time, being female in a patriarchal society and having a disability and being black. But I also try to push her. That's our family way, never to give up and to go for education, and that's what I'm trying to do with Jade. When you see a person like Jade, you see their disability first before you see the person. Not until it really happens to you or it touches your family, do you see that we're all the same. I don't see her disability until we're out in public and people stare.

Jade was born with spina bifida. When she was born, the doctors were very pessimistic. Grandma said, "Look at her! She's beautiful. Get her out of that hospital. She'll be fine."

Jade Richter
Daughter student
14

I'm pretty close with my mom. We have our fights, but she's laid back. I'm very close to Grandma, too, but she worries about stuff a lot.

I live with both my parents but I don't think I'll always live with them. I'm getting to the point where I'd like to be on my own. I'd like to go to college, move to Florida, and become a marine biologist and work on manatees.

Kathy Jordan
Mother teacher
37

With my mom, family was important to her because she never really had that. We had friends, but we really weren't allowed to have company. We had a lot of brothers and sisters and we all kept each other company. I'm like my mother in that I'm more comfortable with family than with outsiders.

Education was really important to my mother, and as long as Maya's doing well in school, I'm happy. She's an adolescent now and she goes through stages where she likes to be alone, but I understand her. We talk a lot and I think she's comfortable and open with me.

Maya Mann
Daughter student
13

I love my mom. She's really close with me and sometimes when we get goofy, we just laugh a lot together. My grandma's really nice to me and I help her out a lot when she asks me. She encourages me to play the piano.

I live with my mother and my grandmother. Grandma drives me to places I have to go most of the time. She drives me to school a lot and every day when I come home, she's always cooking dinner. We always expect dinner when we come home because we know she's going to be cooking it. With problems I have, I'm closer with my mom.

I hope my mother keeps teaching so that when I get in high school I'll get to see her a lot. Once I become a pediatrician, I'm going to help her out so she doesn't have to work. I'll take care of her when I get older.

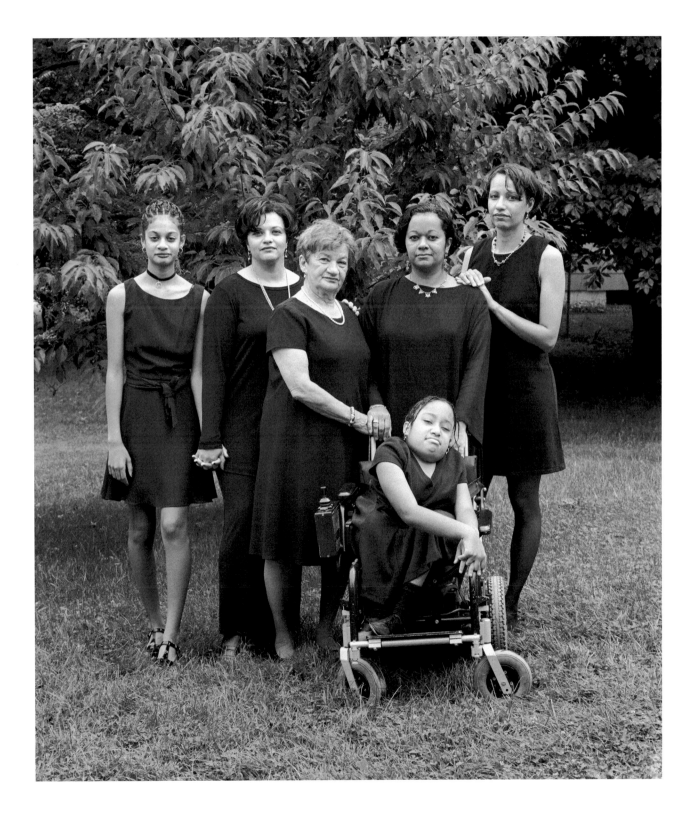

Sarah Rice
Great-Grandmother retired
88

I missed out a lot. I think our whole generation missed out. We were so devoted to our parents, trying to figure out how to protect them. Things weren't in place like they are today, they didn't have Social Security. That means a great deal, you know you're getting something. My parents' generation had nothing to look forward to but debts. We were always worrying about them and that colors your whole life. I always tried to instill independence in my children, and I'll take care of myself as long as possible.

I feel like there are several generations separating me from my daughter.

I don't see many of my qualities in my daughter or granddaughter. So many changes have come about in life and in our customs. I've tried to be very liberal, I've worked at it. I think the feminist movement is good, but I still have my inhibitions and that's one thing I don't accept, the lack of inhibitions in young people.

I am blessed with a loving daughter and granddaughter, and how many people have great-grandchildren? That is my dessert in life, and a great dessert it is.

Wendy Shapiro
Grandmother special events coordinator
57

My mother is a wonderful role model, but not as good a nurturer. I always felt that I was too much for her. She was thirty-one when I was born; it doesn't seem old now, but in those days it was. She did good things, she was my Brownie and Girl Scout leader, but we didn't have a real close feeling.

I was married in 1959 at nineteen, and Laurie was born eleven months later. I was delighted to be a mother so young, but my mother was unhappy because she had wanted me to finish college first. I'm mad about Laurie, I just adore her, but when she was growing up our rela-

tionship was more difficult. We're very different, I'm an "in your face" kind of person and she's much more reserved. I hope she respects what I am, but sometimes I get the feeling that I am overwhelming. And I can be.

The reason that grandmothers and granddaughters get along so well is that they have a common enemy. When I'm upset with Laurie about something and I tell my mother, she has such compassion for her, but if I had done it my mother would have killed me. It may be because it's once removed and you don't have the baggage that goes with it when it's your own.

Laurie Kanter
Mother embroiderer & medical secretary
37

I always felt that my mother was very overbearing, and most of what I remember is rebelling against her, while I'm so close to my grandmother in my heart, and so comfortable with her. When I had a baby girl I saw for the first time that my mother's way came from wanting to protect me. When Ilana was born, she was so reliant on me. I did everything for her, and I can see how you become overprotective and don't want your children to become independent.

I have a childhood memory of not being allowed to have Barbie dolls, and now that I'm an adult, I don't like what Barbies stand for anyway, with their perfect figures and pointy feet in high heels. When Ilana was little we came down to visit my mother and she brought out a case that

had been mine when I was a child. It was full of Barbies and all these clothes that I had made for the dolls. I had sewn clothes and knitted them too, and obviously I had spent a very long time playing with my dolls. Strangely, I have no memory of anything to do with it.

Ilana loves Barbies and clothes. She's just three years old and she wants to wear lipstick, while I never even wear stockings. It feels almost like Ilana is foreign, that she's not of me. She's more like my mother, who has a closet full of shoes and clothes, makeup and earrings. All that stuff is frivolous, and what's it for? What's important in life is living it, not having frilly things.

Ilana Kanter
Daughter
3

Grandma Wendy plays with me. Great-grandma plays with my toys. And Mama plays with me.

I'm going to have a little girl someday and play with her.

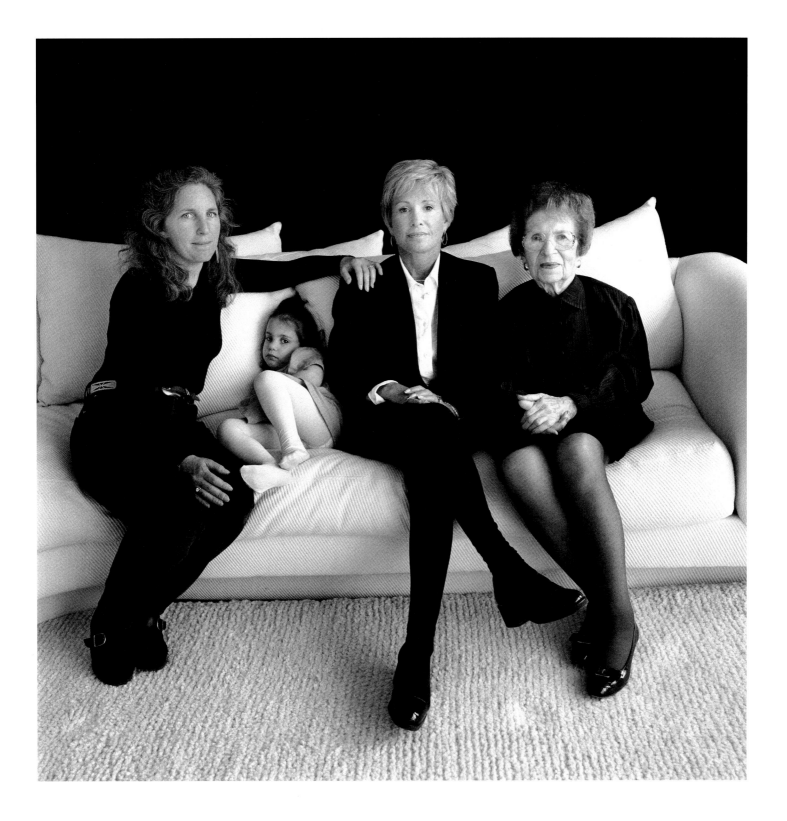

Sarah Gurney

Grandmother housewife
87

My mother was wonderful. That's where we all get what strength we have. She married the wrong man which was very unfortunate, because she was smart and he wasn't.

I adored my daughter, Mary. Mary used to say, "You're the only person who understands me," and I did understand her. We got along beautifully. It's awful to outlive a child. You don't get over it. She wouldn't tell any of us when she expected to go. She said it was her business and she was not going to have her friends bringing her a cup of soup every time she turned around. She was very brave. I have no complaints, but it hurts just the same.

My relationship to my granddaughter, Sarah, is as much like my daughter as it can be. If Sarah gives birth to a great-granddaughter, I would give her the same advice my mother gave me. My mother told me all the facts of life. She told me everything I should do or shouldn't do and I tried to follow that. My daughter, Mary, did the same thing with Sarah. Sarah's a lot like her mother and she grows to be more like her, too.

Sarah Stephenson Keyes

Mother-to-be museum educator
33

I was very close to my mother and I'm very close to my grandmother as well. Being here in Maine has always been as much to me about matriarchy in my family as anything else. When I came here as a young child, my grandmother's mother was here, too. I always watched my mother with her mother. They were more like best friends than mother and daughter. I was so close to my mother when I was little that at times I was jealous of the relationship my mother had with her mother.

My mother was a fiercely independent woman and as I was growing into that, we would often clash. In the last few years of her life, when I met my husband and was married, I began to replicate my mother's life and we found a new way to bond and be together.

Three months before my wedding, my mother found out that she had terminal cancer and was given three to six months to live. She was determined to walk down the aisle and dance at my wedding and she asked my father not to tell anyone that she was dying until after the wedding. When I learned she was ill, being a stubborn daughter I was hurt she hadn't told me sooner so I could have spent more time with her. For her, it made the whole event a celebration of life, not of death, and in hindsight, it was the greatest gift she could have given us. There was a lot of powerful energy that day, not only because it was my wedding, but because there was a coming together of true, unconditional love that this place has for us, and particularly for the women in our family.

I have always thought of Maine as being the touchstone in my life because my mother and grandmother were here. We scattered her ashes in the ocean in front of the house. There's a real sense of place and belonging here, and of loss and rebirth. Being with my grandmother and expecting my first child, I realize the loss of my mother very painfully, but at the same time, so much of my mother is present in all three of us. I found out I was pregnant on my mom's birthday. It symbolizes the regeneration of life for me.

I think about the possibility of having a daughter and part of me lives in fear that a lot of my mother will be in my daughter. I'll have my work cut out for me. I think she'll be a strong-willed and independent young woman. I look forward to that. As times change and the world is such a frightening place in many ways, having a sense of self-identity and a certain amount of independence is a great gift.

Our daughter will be named for my mother and for her great-grandmother as well. My great-grandmother's name was Mary Hall and my mother was actually named for her. We've alternated Mary, Sarah, Mary, Sarah, through the generations. I'm named for my grandmother.

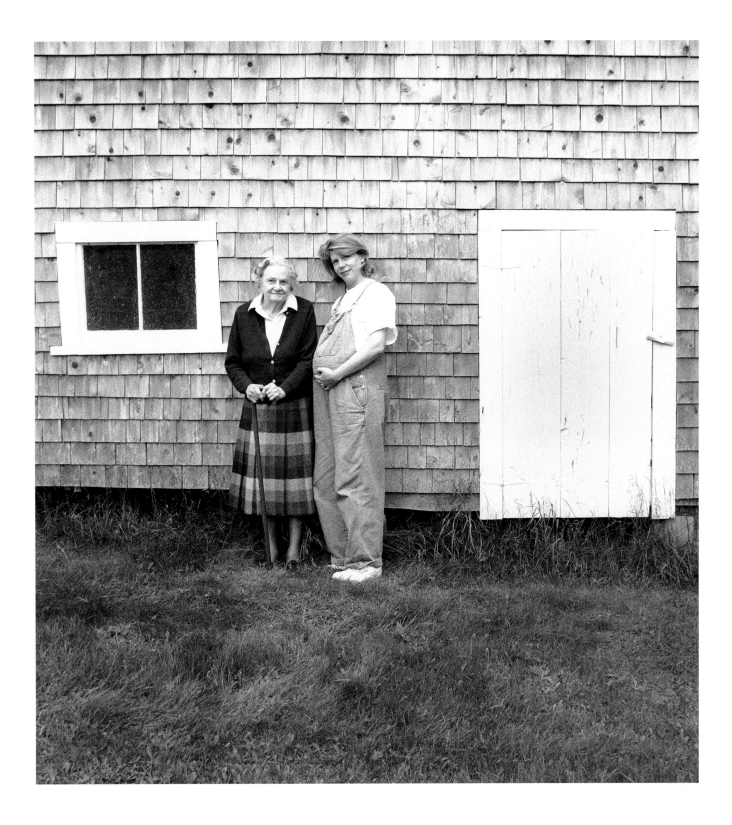

I was encouraged to feel the rhythm, enjoy it, and pass it on. Hopefully, I did that.

As my mother's daughter, I'm glad I know where I'm headed because I can look, listen and hear, and see remnants of my future. My daughter, as my daughter, appears to be the best of the

The greatest thing that I learned from my mom, that I've passed on to Amarah and hopefully will pass on to Jerzey, is to work hard at whatever you do and *always* keep it real.

Emma Johnson
Great-grandmother world traveler

Whoopi Goldberg
Grandmother human
41

Alex Martin-Dean
Mother singer
23

future. My granddaughters, now they're just a whole other animal. Those two girls will be running the world, and of this I am positive—just look in their eyes!

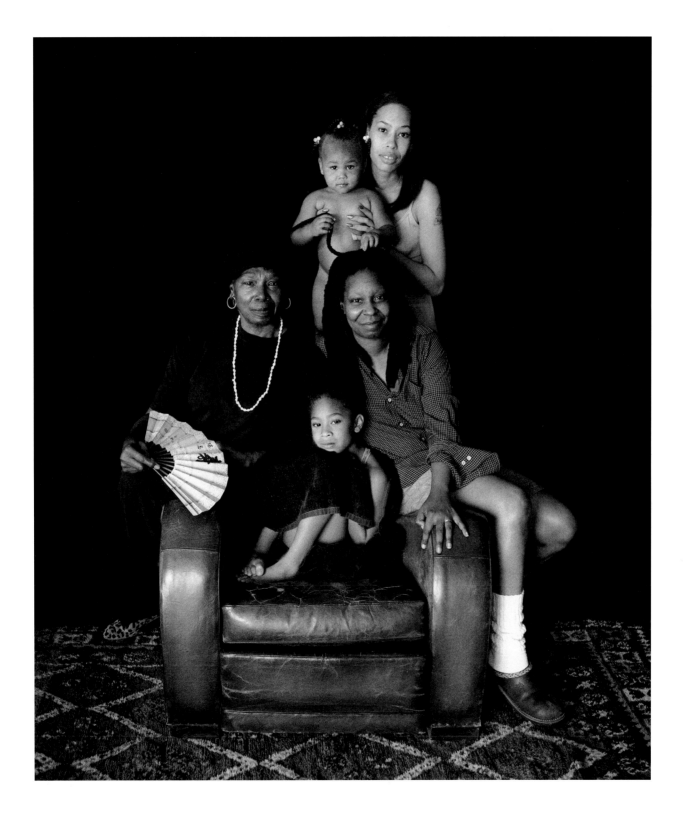

Patricia Doyle Cheap
Grandmother housewife
64

My mom's fantastic! It's just such a blessing. We've had a wonderful relationship because until the last four years we've always lived near each other. And we were really pals. As she's gotten older, it's been hard to accept that she can't go shopping and run around town all day like she used to. That was a shock to me, and her physical frailties kind of bother me now.

I have four daughters and we're all close. We go places together and everybody's married and has their own family now. I feel like I am an anchor, which can be good and bad. It's good because you're never going to be adrift and it's bad because it can be a little stifling or confining. I can't say that I know my sons like I know my daughters. I know my daughters intimately. But my sons—I kind of know them, but I don't—it must be that Y-chromosome. It's a different relationship with the boys. They're not interested in the same things I'm interested in. With my daughters, we talk about everything, from recipes to child things, kid problems, how did I deal with it and how they deal with it.

Pamela Huntoon
Mother volunteer
40

My relationship with my mother has always been very close. I worked with her for almost twenty years in a business, so of course we had our moments. My mother always taught me that something should be done right if it's going to be done at all. I'm trying to do that with my daughters. Brigid's thirteen and a half, going on eighteen. She's so different from me. I don't remember a relationship with my mother like the one I have with Brigid. Sure, you don't want to be caught dead with your parents, but I don't remember such animosity. These kids have so much more to deal with. I'm trying to respect that and listen, even though in the back of my mind, I know better.

Brigid Huntoon
Daughter student
13

I know this is kind of strange, but I've always felt like my mom was more the daughter. She's more outgoing and I'm kind of shy. She's more wild than I am. We're total opposites. I guess we're more like friends than most moms and daughters. If I have a daughter, I hope we'll be friends. I'm not really into that hugging thing. It's not that mothers hug all the time, just a little more than I'd prefer. It's embarrassing to me.

Karen King
Mother artist
42

I'm the oldest daughter of seven kids, so I have a great relationship with my mom. I pretty much got the best of everything because my mom had enough energy for me. She also encouraged me to do the things that I liked to do, which were studying art and taking time out for myself. She also taught me how to clean house since I was the oldest. It was very much a give and take kind of relationship where I knew if I did these things, then I would get to do other things. I don't have any pain with my mom. She was always my mentor as far as her attitude about life and raising children and just being a good person in the world. She taught me how to take everything for what it is and not get everything all complicated and chaotic and make a big deal out of things that really in the grand scheme of things mean nothing.

Kaitlin King
Daughter
8

My mom is nice and cheerful. We both like to draw. We go over to my grandmother's house sometimes just to be with her.

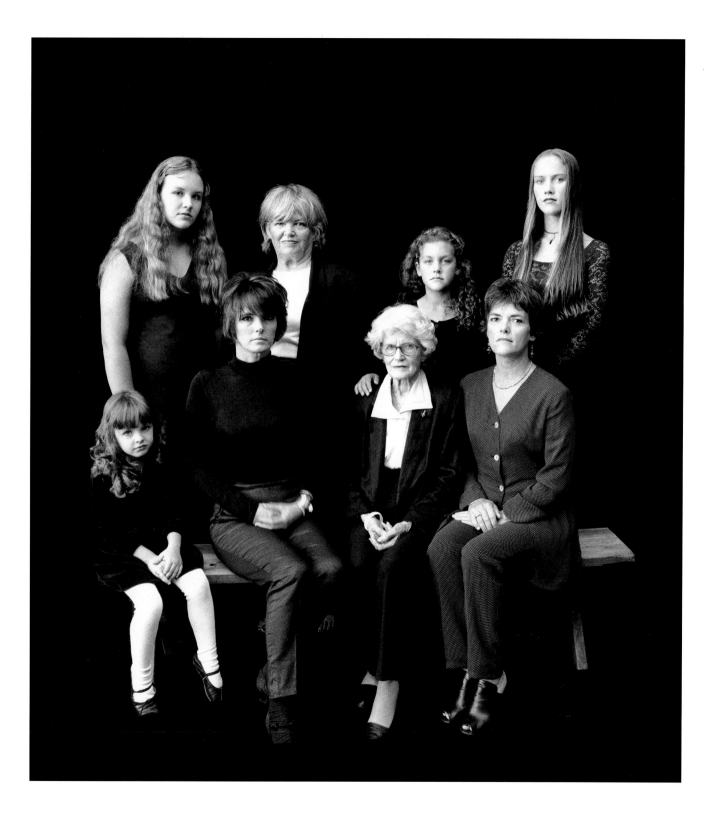

Kathleen Klepl
Grandmother office manager
52

I'm living with my mother right now, I moved back to take care of her. When I was growing up there were a lot of things we just didn't talk about. The women's lib movement began around when I got married, but I didn't feel the effects of it. I was a child of the early sixties, when you were expected to get married and have children, and that was the end of any career unless you were a nurse or a teacher. I was taught that I should go to high school, but that college was only good for looking for a husband. Later on, when I had to go to work, I felt that maybe I had made a mistake not going to college and getting on with a career. Times have changed drastically from when I grew up. There's a lot more opportunity for a woman now. I want both my daughter and granddaughter to be happy and to do something with their lives that makes them feel fulfilled, not used or just fulfilling the role of mother.

I think I've had a little better communication with my daughter Becky than I ever had with my mother. I was a single mother only for a while when Becky was nine. She's started off that way. Becky's being a single mother would not have been my first choice, but it's much more accepted now than it would have been if I or my mother had done that. I don't think it's a stigma anymore, and it won't matter to my granddaughter Brooke.

Becky Klepl
Mother waitress
20

I am twenty and my baby is nineteen months old. I didn't want to get pregnant, but when I did I made the choice to have her. It is really hard to raise a child by myself, but I think I'm doing a good job. I get to work at five-thirty in the morning, and before that I take Brooklyn to my girlfriend's house, lay Brooke in bed with another kid, and she falls right back to sleep. I get off work at two o'clock in the afternoon and go pick her up.

I want my daughter to be happy. I've always wanted to be a "Kool Aid Mom." I want to be the coolest mom on the block, where all the neighborhood kids come over and say, "Oh, Brooke, your mom's so cool. She bakes great cookies and you have the best toys. It's so fun over here."

My mom and I never really got along that well until I had a child. Before that, I never appreciated all the things she did. My life is different from my mother's because times have changed so much. My mom would never have been a single mother, she would have stayed married no matter what. Now, being a single mother isn't cool or trendy, but it's accepted. When I was young my mother was happily married for a long time and we were a whole family. I want that for myself and my daughter. I never married my boyfriend because I knew it wasn't going to be forever and I don't want to get divorced.

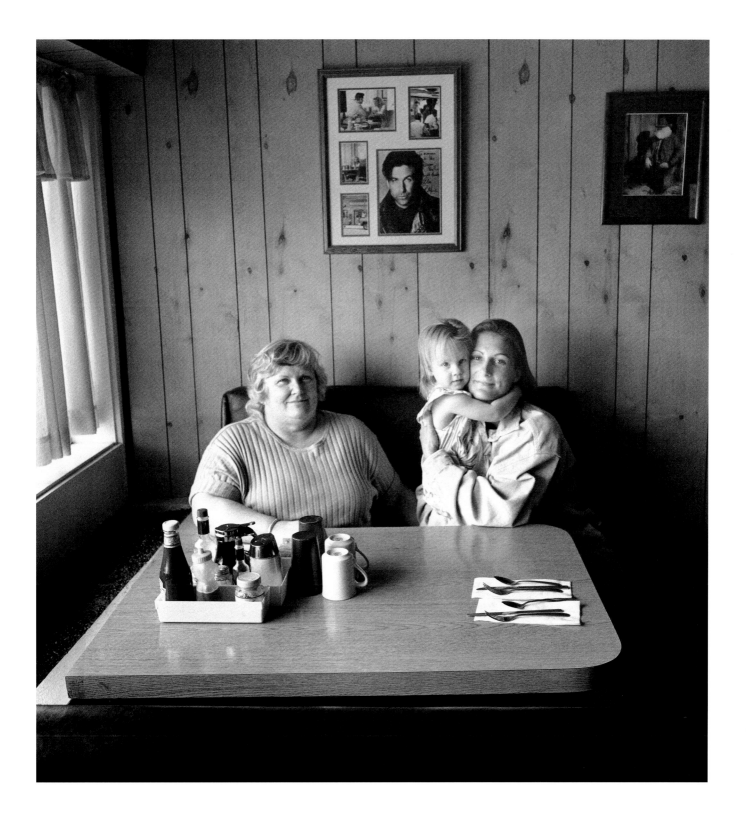

Alison Knowles
Grandmother artist

My relationship with my mother was always strong and full of humor, with many light jokes and jests about very serious matters. We admired each other, but I didn't know her really, nor did she know me.

The relationship I have with my twin daughters is very different. Women's situations and how we relate to one another have changed so radically throughout the human community. My daughters are warm friends to me and vice versa. We seem more like sisters, except that I'm bigger and older. We travel and work together as artists and teachers, our connections to one another existing outside the family scene as well as inside it. With my granddaughter, Zoë, I don't really feel the distance of generations either. She is just my little new friend. In this case, I am a lot bigger and a lot older.

Jessica Higgins
Daughter artist
33

Alison is beyond words for me. I cannot express the feelings I have for her. I'd need to create something never made before, like a color, gesture, idea. As an artist I struggle to find my own voice within the expression of life she's given to me.

Hannah and I are fraternal twins; there is a special understanding between us. She showed immense support for me when we were growing up; at times it felt like we were challenging each other to discover wisdom far beyond our years.

My niece, Zoë, awakens something in me and I find myself smiling.

Hannah Higgins
Mother professor and art historian
33

Eighteen months ago my mother fell off a ladder into a light table. My sister lives a few blocks away. She left a message on my sister's answering machine. "I've had a rather serious fall, please come to the loft when you get this message." Hearing the message, Jessica ran to her house in her pajamas. It was three in the morning and raining. Alison sat in the middle of the room with a red towel, originally a white one, wrapped around her head. Jessica gathered up three or four teeth, put them in a glass of milk, snatched up a photograph of my mother, and called an ambulance.

Twenty-one years ago, Jessica fell through a glass window as she tried to stop a door that was swinging shut too quickly. Her hand went through and there was a terrible racket. I was upstairs. No one else was home. She called up casually, "Hannah, I think I may have hurt myself, come down when you get a chance." I went downstairs and she was standing calmly in the middle of the dining room looking at the top of her arm, from which there was a steady drip of blood onto the floor. We turned her arm over and started walking to a neighbor's house to get a ride to the hospital. She had thirty-three stitches that day. I was back in time for my part as the witch in Hansel and Gretel in the school play that night.

I have never had a major injury. These women are remarkable in part because of how they have borne theirs. Jessica has a scar on her arm. It used to be bright blue, now it's just shiny, white, and feathery. It looks like an umbrella over a calm sea. My mother didn't scar at all, but once or twice I have heard her cry out at night. Both of them are artists. I am an art historian. They make. I comment.

48

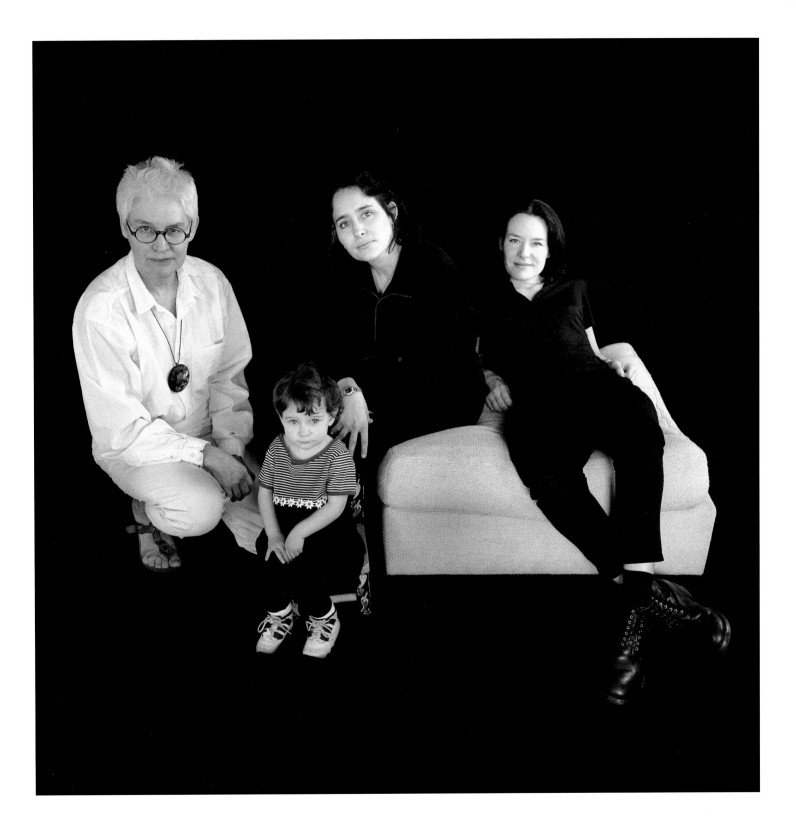

Georgiana Lewis
Great-grandmother housewife
93

I learned a tremendous amount from my mother, mostly determination. I hope I passed that on to Susan. I admire her tremendously. I don't know her very well, because we don't live near one another, and I don't insert myself in her life much. I accept what I'm told and don't question.

I don't know my granddaughter, Copie, very well. I was upset with her first marriage and I've never quite forgiven her for that. I don't see them very much. It's their fault. I don't live near them. I'm very busy and they are apparently very busy, too. I haven't the time to be more involved.

Susan Lilien
Grandmother housewife
67

I had a very difficult relationship with my mother, who has always been self-involved and not really interested in her children. I always tried to rebel. She says the most important thing to give a child is discipline and I say love. My sister and I were brought up by German nurses and I think we were always frightened. There was nobody to talk to or go to if something was wrong. That's really terrifying. When I was twelve years old I couldn't go to my mother and tell her the dentist was molesting me. My mother wouldn't believe me, so I took my grandmother with me to the dentist for the next three years!

The children didn't come first in my mother's life and I told her this two years ago. She was quite shocked. She hadn't realized it and asked if she'd been unpleasant for years. I said she had been, and now she's trying much harder.

I've tried to get along with my two girls as well as I can. I adored them and I like to think that we are great friends now that they have grown up. Copie was Miss Wonderful until she was seventeen, when she took a "terrible" pill and started rebelling. A late rebellion is much more difficult than an earlier one, but she matured and everything worked out fine.

Copie Lilien
Mother executive trainer
41

My mother is legally blind. Sometimes that was hard, because I literally needed to guide her at a very young age. It helped me become confident and self-reliant and able to navigate things well. Her blindness helped develop other senses in me, because her senses are so acute to help compensate. If I'm searching for something I usually don't use my eyes, I reach and I feel all around for it, and I never think to look. Looking is always the last thing I'll do because I never saw my mother look. She would always be saying, "Oh listen, listen, what's that sound?" So from a very young age I remember listening and I still hear and smell and taste things acutely.

My grandmother is amazing because she has so much energy and she's never seen her age as a limitation. Nothing stops her. That's been a tremendous lesson. I almost take it for granted that at ninety-three people can be independent and travel all around the world.

I think my daughter, Cammie, and I are very close; it's kind of hard to tell now, because she's a teenager. She is intense and poetic. I think we are profoundly connected, whatever the surface might look like at the time. I'm learning to let go with both my kids because they want to be independent and I've been a close presence.

Cammie Kelly
Daughter
13

My mom and I are very close and I have a lot of respect for her. We are alike in some ways, but as I am getting older I am noticing more differences. It's natural, I guess, to grow apart from your parents in adolescence. Both honesty and strong communication are things that I have definitely learned from her, because she is a strong believer in talking to me with no lies.

If I had a daughter, I'd hope to be close to her and be able to talk to her. I also hope I would let her grow up by herself and be very individual, because I'm having trouble feeling that I have freedom.

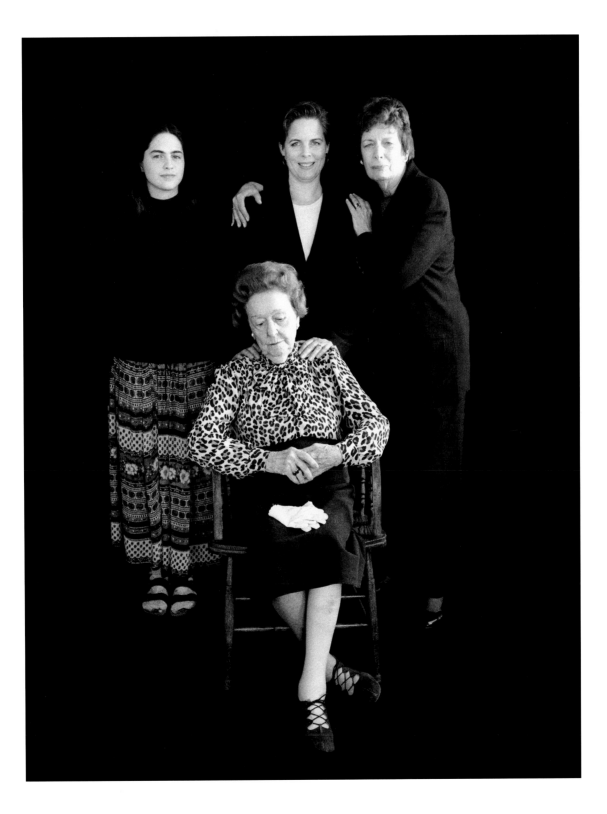

Cecily Littleton
Grandmother gardener
69

I was the oldest of five children and the only daughter. All the emphasis in the family was on all those little boys. I grew up being faintly ignored and never got taught how to be a girl. When the war came along my parents went over to America because Daddy was appointed to something or other, and I was handed out to an aunt. And that was fine; I mean it was just sort of the way everybody expected to live. Unnatural families, because the war was a mess. There wasn't a normal, peaceful family life. Perhaps family life isn't peaceful.

Sophie was my third child, and she was always a rebel because she had to be different from the other two, which is just what Eliza's all about. She always wanted to wear different clothes. Uniform said you had to wear a blue sweater, so she had a blue sweater with red all through it. When she got to university, she'd already discovered that she was smart and tough and knew what she wanted.

Sophie's being such a good mother. She's patient. I don't see her and the girls enough, about twice a year, because they're too far away. But the other thing is I'm no good on the telephone—I can't babble.

Sophie Behlen
Mother teacher
40

My relationship with my mother is good now, there's a lot of distance between us and between now and the time when we lived together. With that, a lot has resolved, and it's a comfortable and nice relationship. Living together was not easy. I think my mother felt that the job of mothering had a great deal of duty, which of course it does, but I think she felt that you had to do certain things in order to make your children be the right kind of person.

In our home environment intellect and critical faculties were the most highly prized thing. Unfortunately, that often turns into just being negative. From early on, I fought, but I didn't know what I was fighting and what I was fighting for. It took me until I was in my twenties to learn not to speak in a fighting kind of way, and to have ears and try to understand what a person is saying.

It struck me when my first daughter was born that everything is already inside this tiny creature in your arms. What happens after that says a great deal, but the material is already all there. My attitude may be too opposite from my mother's, but the pendulum keeps swinging.

I see something really marvelous in each of my daughters' natures. I have allowed them space, and I am sure that I give them too much power because I felt so powerless as a child. I may have given away some degree of authority for humor. I think that's really valuable for them because the relationship is going to change one day. They'll be grown-ups and I won't be the authority. Humor is important for giving some resilience to the relationship.

Emma Behlen
Daughter
12

My mother and I are very different. We don't have the same views about a lot of things. If I had a choice, I'd want our relationship to be a little less authoritative. It's always been more like, "You're gonna do this," and I don't like that. I need more freedom. Maybe we could relate to each other better as individuals.

Rebecca Behlen
Daughter
10

My mother is rather a lot like Grannie. She's got the same personality. They're both just a little bit picky and negative, and then they're fun sometimes, too. My sister, Emma, is really nice and we can have a lot of fun together except sometimes she can feel very in charge and orders people around and that's not so fun. Eliza is pretty annoying but I play with her when there's not a lot else to do.

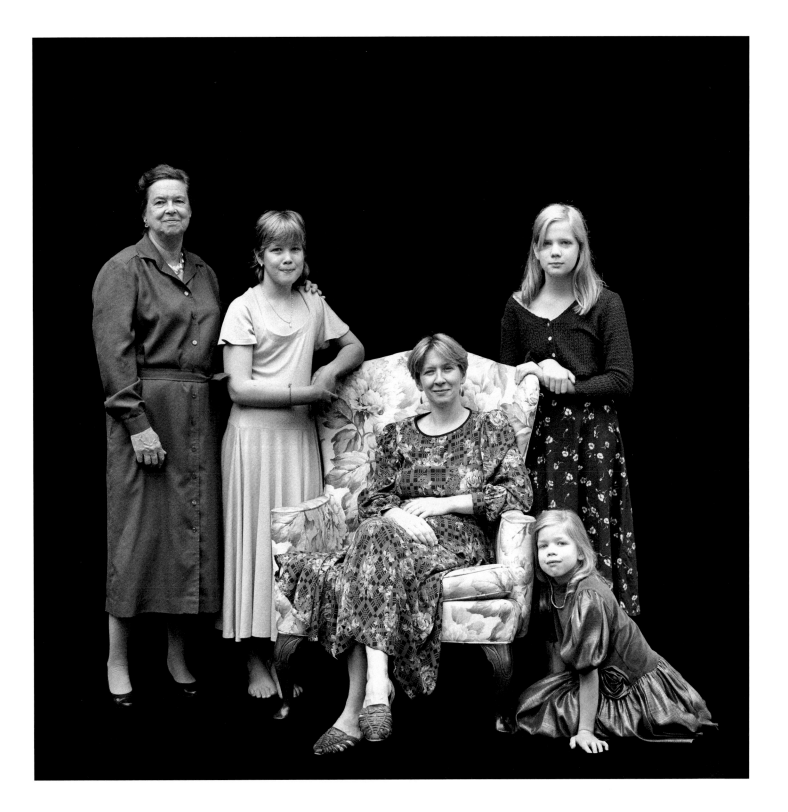

Marina Ma
Grandmother housewife
73

I was born in Hong Kong. When I was two and a half I lost my mother but I know she was a wonderful person because a servant told me how she treated people. We had some musical background in the family, and I majored in singing.

My daughter is a wonderful daughter. She is smart and she is also a very good mother. She loves her children, takes care of everything for them, gives them a good education, and lets them also learn music.

My granddaughter, Laura, is very intelligent. She loves to dance and she has a golden voice. I think she inherited her beautiful voice from both sides of the family. When she was only about three I saw her pick up two candies at a party and give one to her brother and keep one for herself. It surprised me that at that age she was so thoughtful. I'm so proud of her.

Yeou-Cheng Ma
Mother musician and developmental pediatrician
45

My mom is a very artistic person. She is in some ways very impulsive but she has worked hard to be patient. She had to manage with two children in a very difficult environment when we were small. She always saved a little extra for us and made us little treats, so she has taught me how to take good care of my children.

My daughter in some ways is very much like my mom in that she is quite sure of what she likes, but they are two generations apart. My mom came from a generation of Chinese women very few of whom went to college or abroad. So it was almost historic. My brother noted that there may be just five hundred women from China in that era who crossed the ocean and went to school abroad.

In my mom's day there were certain prescribed roles for women, and it was generally accepted that moms would stay home and raise the children, as she did. I was afforded the greater opportunities of going to high school and college in America in the midst of the feminist revolution. For a while, I believed that women could do everything, but then I realized that that may be true but they can't do everything at the same time. I've done double-time trying to juggle two different professions and child rearing, and sometimes I do a good job and sometimes I fall flat on my face. It's been challenging.

My daughter is terrifically articulate and she knows what she wants and she usually gets it because she is so clear about it. In some ways this makes me terribly proud and in other ways it makes me just slightly worried that she might be a little too assertive. But I am sure she will be very good and come to her own peace quite nicely.

Laura Dadap
Daughter student
10

My mother is OK, but sometimes she can act a little weird. She makes things up to get my attention, and it seems strange, like adding things about elephants, which have nothing to do with the story, when she reads to me at night.

I've learned special hints about life from her. I feel good that I do have a mother, because in some books children don't, and it's very upsetting. My mother is very helpful when I practice the cello and the *banduria* because she has special little tricks to help me remember everything.

I don't see my grandmother that much, but I think she is a very exciting person because she travels a lot and she brings me stuff from all her trips. She gives me presents at every holiday; she never forgets. She is a very thoughtful person. I remember once she was babysitting with us and she was helping my brother with the piano and she was pretty good and I felt strange because I never knew that she could play an instrument. So I don't know much about my grandmother, but I think she is a wonderful person.

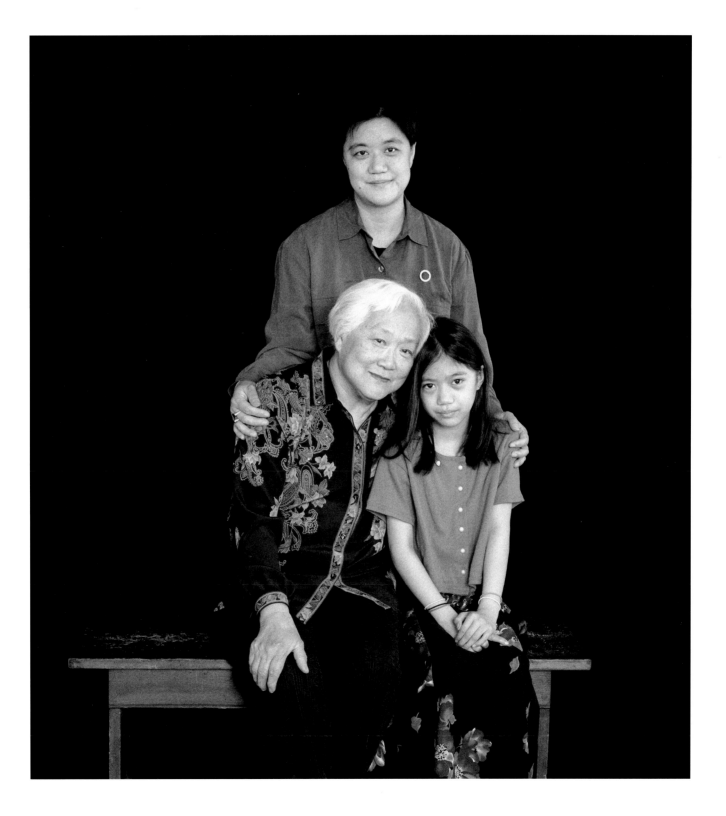

Helen Terry Marshall
Grandmother artist and retired teacher
88

My life was never typical. We've had women making up their own minds and doing what they thought best since my grandmother's time. I didn't have to change the pattern; it was done before I got here.

My grandmother was married when she was seventeen years old on a plantation in Louisiana. When her husband was having an affair and it became a scandal, she got a divorce. That was soon after the turn of the century, at a time when women didn't get divorces. I was told it shook the whole area.

My mother was staying at home taking care of us children when the First World War came along and my father needed someone to keep the books for his drugstore. My mother had been to college, so she went to work, but because she was a woman they didn't want her to be in contact with people, so my father built a place with a curtain over it so you couldn't see inside.

My mother expected to be obeyed. When my daughter, Terry, came along I didn't feel that way at all. There wasn't anything on earth I wanted like having children. I just wanted to love the little thing and to have her love me and to have a good time. And we did have a good time together.

Terry Marshall Williams
Mother retired teacher
60

We all have a very close relationship. When my brother and I were children during the war and it was a scary thing if a plane flew over, we felt that even though my mother's short and small, she could keep all the danger away. She was our person who made things safe.

We would go for walks in the woods and have picnic. We were always looking for treasures and finding interesting things. I noticed that when my children were coming along, they were doing the same sort of thing, so it was handed down. It was just seeing the beauty all around you at every little turn, the magic in life.

My mother's eighty-eight now and I take care of her a little bit, when I can catch up with her. She has less fear about things than I do, she's always been ready to go off on her own to see the world. That affected my children, who would be climbing trees, making things out of clay, putting on plays, and creating magic shows in our yard, which was always where everybody gathered. Other people were busy cleaning up their houses, but my daughters were always doing things around our house. They were creative from the very beginning.

Renee Williams
Daughter partner of gallery and frame shop
31

My grandmother always had a lot of art supplies and we got to sit in on art classes when we were kids because she was teaching college. Both my sister and I are artists and that's because of my mother and grandmother.

My life as a woman is different from my mother's. I don't plan to ever have kids. It's already hard to do art and run a business, so I can't imagine having a third thing. And a child would have to come before those two things. I would have to be one hundred percent into it and want to have that be my entire focus for the rest of my life and I can't imagine that.

Dee Williams
Daughter artist and medical receptionist
35

My mother and grandmother have both been strong figures for me. I've learned how to live life from them and I can draw from them in my work. From my grandmother I learned to live with a lot of energy. My mother taught me to see things from an overall picture. My art is about representing myself as a woman and it's a lifelong quest to decide in what ways I want to do that.

I don't want to have children because my life is devoted to making art. I don't see how I would have the energy I think it would require to have children. My mother's and grandmother's lives were really focused on having children, which was good because it gave us what we needed to live.

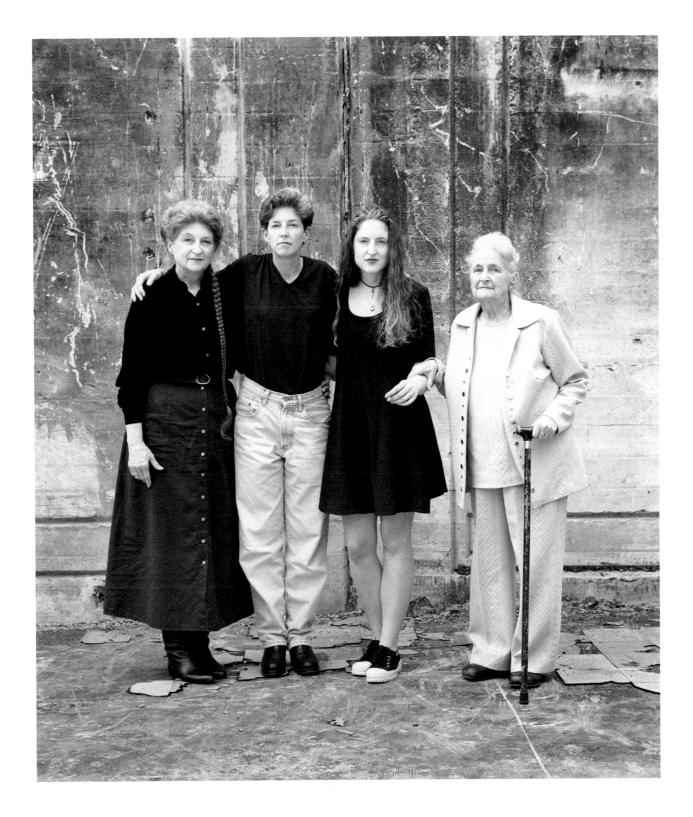

Katie Clare Mazzeo
Grandmother musician
68

I admired my own mother enormously. She was an Austrian who came here when she was a young woman. We used to go out and draw together and she taught me how to see. She was a loving mother and very domineering. I was an only child, so I didn't want to have just one and I urged Rima not to have just one.

My relationship with Rima is very different from the one I had with my mother. During her high school years it was not great, but then whose relationship with their mother is good in the high school years?

All in all, it has been extraordinary because we have been like sisters.

It's one of the best things in my life. We have a wonderful time and she looks after me. It's a great joy to see that she's continued many friendships I have, that they've become her friends too. She has a great sense of vitality and interest in living.

Madeline responds very well to music; I think she has a fine rhythmic impulse and she's well coordinated. I have no doubt she will be talented in whatever she will be willing to discipline herself in. I teach piano, and I would love to teach Madeline, but it will depend on her. It may be that she will need an outsider to respond to in a more formal way.

Rima Mazzeo Crow
Mother chef
39

My relationship with my mother is wonderful. She is my best friend, but I hated her when I was a teenager. She wasn't permissive, so I went ahead and did whatever I wanted and ignored her. Then I didn't talk to her for a few years and moved away. Since then we have become really close. I live around here so I can be around her.

She has a joy of life I would like my daughter to inherit. I see things I don't want to pass on, but there are a lot of good things. I'd like Madeline to have as interesting a life as my mother has. My parents have had very round, open, big lives.

Having Madeline is like having a little sister. I never had a sister. She is scarily intelligent and a born performer. She has been very sure of herself since she was born. She's a fun person to know.

Madeline Crow
Daughter
4

My mom takes me fun places, like the merry-go-round. I like that music. My piano playing is really pretty, but I have to get the notes right. I know how to dance. I went to ballet class and I watched the *Nutcracker*.

When I grow up I want to work in the new store that's coming. I want to play the piano, but my mom said I have to work in the store at Bob's Gas Station, so that's it. I'll be a musician, but it'll be a lot of work to learn first.

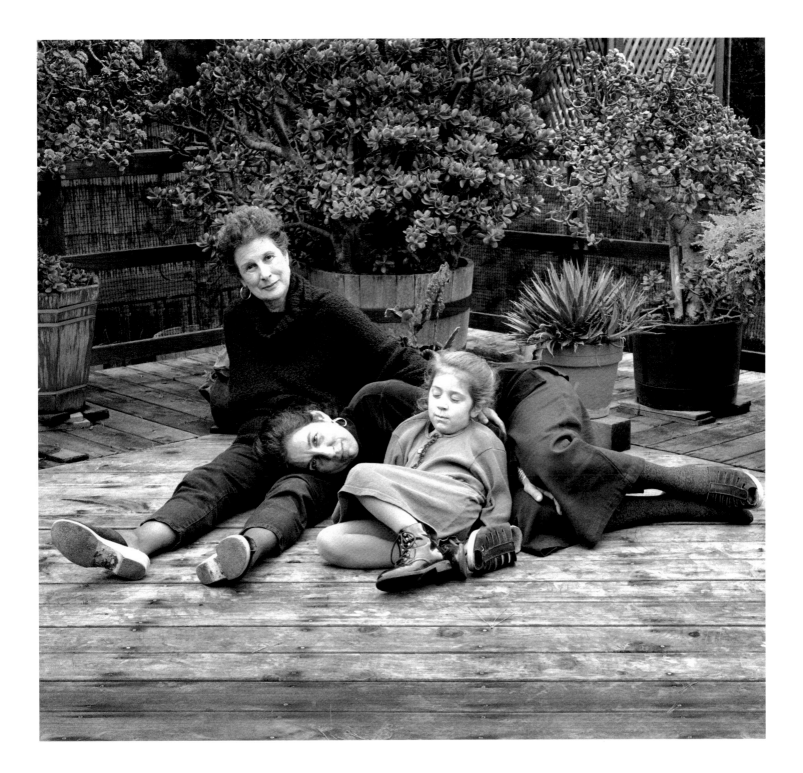

Carol Moses
Grandmother retired educator
64

My relationship with my mother was much more structured than my relationship with my daughter Amalie. I was born in 1932 and that was a different era. I don't think parents were as at ease with their children then. I never had a really close personal conversation with my mother. I didn't go to her when I needed help, I went to my siblings or to a good friend. I did have a close relationship with all three of my daughters. We did things together, we laughed a lot together. I was much more informal than my mother was with me, not that there weren't rules. There were lots of rules.

I have a lot of blessings, but my family is the greatest one. And I've been lucky. If I made a mistake, it was that I was too much on top of them, probably more than they needed when they were growing. I thought I supervised comfortably, but I had too close a distance rather than too great a distance. As I look back on it, if I had to do it again I'd give them much more autonomy. Children have to have autonomy and independence to learn how to cope with the world. I think I was overprotective because I cared so much. In the long run, it's not a good thing to be.

Amalie was born with a smile and she was born giving. You always get much more back from Amalie than you give her. No matter what it is, the sun, the moon, the stars, you get more in return. That's the way she is with her friends also.

My granddaughter Clarissa doesn't know me well yet. Unfortunately Clarissa won't remember me. I know statistically about how much longer I have to live, which isn't a great deal. I'm realistic about my illness. I don't have any anxieties left about anything because I recognize where I am in the bigger picture. I'm very comfortable with myself and very comfortable with my relationship with my family, which is the most important thing to me. I only spend my energy with my family and close friends. I'm not interested in anything else at this point because I have limited energies.

I'm so sick, so very sick, and I know I have to go. When you're that sick and you have no quality of life left, your mind helps you. Some months ago, real life meant nothing to me. I was so disconnected from the world that I had a vision of people being puppets with strings being pulled by somebody. There is something out there that is so big, and we are totally insignificant. My mind was very much at repose, at rest, peaceful and tranquil. I think you only really recognize that when you've had a near-death experience.

I have much more energy now but I live a very limited life. What I do has quality and it's wonderful. The longer I'm around, the better. I like it. If you have no quality it's something else, but I've got this most wonderful life—eight grandchildren. One of the things I'm going to miss most is seeing my grandchildren grow up. If I were to give advice to my grandchildren it would be, live every day because life is short and you only live once.

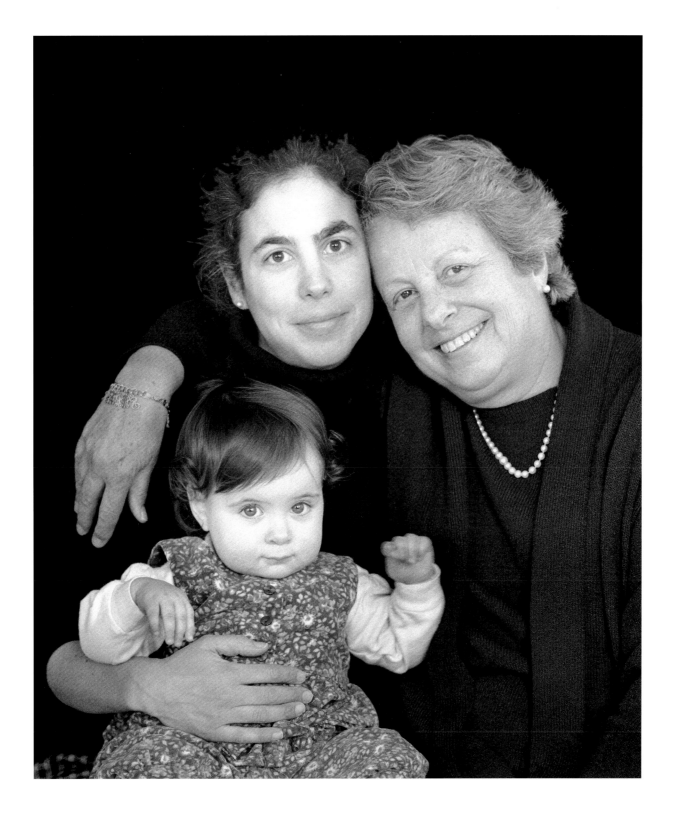

Deborah Olson

Great-grandmother retired hospital dietary
department supervisor
81

My mother's family came from Norway. My parents were not affectionate; they were distant and you learned to respect them. I know they loved us as much as we love our children but they didn't show it.

My girls and I have always done things together. I never felt older than them. We've all grown up to be independent people, each one taking care of her own needs but being there for companionship. I feel that I have the same relationship with my granddaughters. I'm the grandmother they enjoy and love to be with.

My daughters make more decisions than I ever did. My oldest daughter, Lois, lost her husband when her three children were small, and it forced decision-making on her. They are all very independent. Our pastor told me he would like the recipe I had for raising my five daughters because they're so independent, except I don't think that was all me; I think they're naturally like that.

Some of them are farmers and, of course, that's what we were. We farmed up until my husband became sick and then we rented the land out. I still have the farm. I get to go out and see when they're working it. I'm still a farmer at heart.

Lois Adsem

Grandmother business manager
52

Mom's always been here for us. After I was widowed I relied on Mom for a lot of the support that I didn't have from a spouse. Mom has always been a rock as far as keeping our family together. We are a very close-knit family; my sisters' children are like sisters and brothers to my children. Now, as Mom's getting older, it's hard to understand all the things she goes through. Like now she needs help with her finances, not because she needs money but because she doesn't care to handle it. She's reverting back to her childhood in a lot of ways.

My daughter Kelly and her husband moved back near us so that their kids would know their grandparents. We are very lucky to have this opportunity to be able to go to church and sit with my mom and bring my daughters along. I don't think that happens in many people's lives.

Linda Engraf

Grandmother farmer and rancher
51

I'm always busy. We have calves and we farm a lot, too. I cut grain and hay and I check a lot on the cows when we're calving. I enjoy what I do, but I can't say that I'd want a younger girl to work as hard as I've worked or to do the manual things that I do. I want more than that for them and to have a happy full life with enjoyment in what they choose to do. The work I do was my choice and I'm not unhappy with it except that now that I'm getting older it gets harder to do some of it. I love the outdoors and I get to spend a lot of time out there doing what I do.

I'm closer to my daughters than to my mother. My granddaughters and I are close. We're almost more like friends. My kids have always been close to Mom, too, maybe closer than I am. They spend a lot of time together. The quality of life here is very good, but I don't think it's realistic to expect my children and grandchildren to stay when our population is declining all the time and there aren't jobs here.

Shelly Siewert

Mother human service aide
33

I'm fairly close to my mother, but I feel like I have a more open relationship with my daughters. It's easier to be a mother than it is to be a daughter for me. I didn't feel that I could be as open with my mother as my children are with me.

My grandmother is an important part of my life. I see her on a weekly basis and I can't imagine what it would be like without her. I don't feel there are as many expectations from my grandmother as there are from my mother. My grandmother accepts me the way I am, whereas I always feel I need to strive to be what my mother expects me to be. I think she expects me to be perfect.

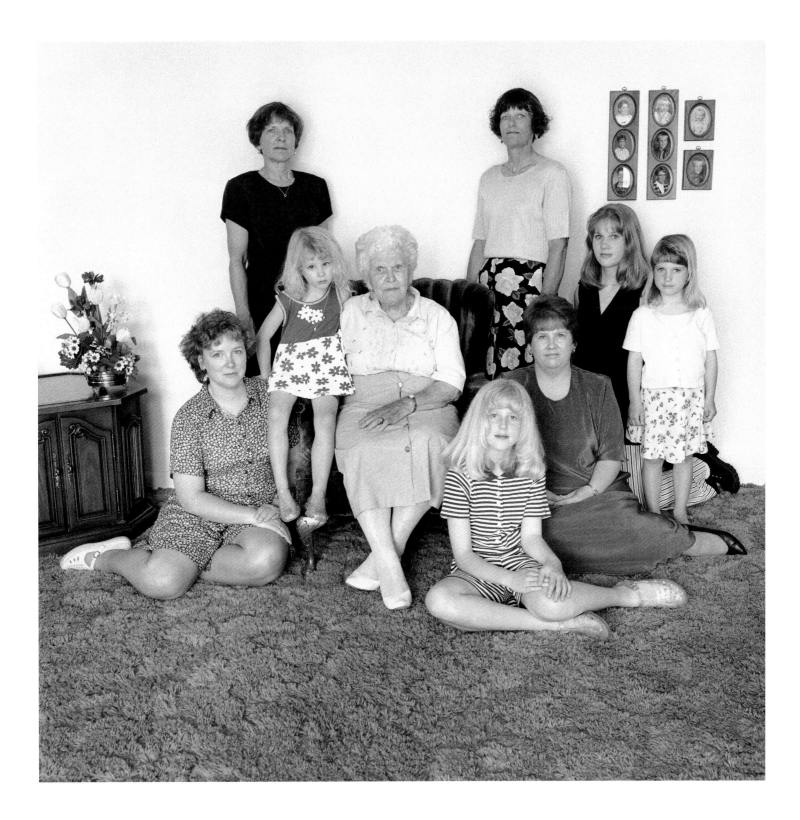

Anna Perales
Great-grandmother retired baby-sitter
63

My mother died when I was young, in Puerto Rico. She was very strict, but we grew up close, nine children. Then she got cancer and died about six months later. My relationship with my daughter is different because Anna's a strong person. Some things that we do, I wouldn't have been able to do with my mother, like talking. If Anna needs advice, she comes to me. My daughter, granddaughter, and great-granddaughter live with me in my house. I raised my granddaughter, Felicita. Her mother wasn't here much. First she was working, then she had a problem and took to drink. She's stopped now. She and Felicita have become very close. In our family, everybody calls me Mama. And then their mothers, they call them Mommy.

I got mad at my granddaughter when she got pregnant so young. But it wasn't going to change; we don't believe in abortion. And now, I'm very happy because she's trying to continue what she was planning to do, finish school and have a future. I hope that she does it.

I hope my great-granddaughter looks back, if I'm not here, and that they explain everything to her and that she doesn't have kids so early in life. I'm writing a book for my great-granddaughter, explaining things about life for her because sometimes the devil is right there in front of you.

Anna and I have our fights, but about a second later we are back talking to each other. We do everything together. Sometimes we disappear and go to the mountains, or weird places like the cemetery. I love her dearly. I don't know what I would do without her.

Anna Perales
Grandmother retired podiatrist's assistant
40

I've been with my mom all my life; I've never left her. She's like my buddy; I'm very protective of her. I got pregnant with Felicita when I was twenty-one. My mom was good enough to me to let me stay with my daughter and live in this house. And I felt that I owed her, that I should be with her. I don't like to leave her alone. She's got a bad little heart. I take care of her, just like she takes care of me. My granddaughter, her great-granddaughter, is just crazy about her.

I have a good relationship with my daughter even though there are times when I do have to go off totally on her. She's seventeen and she thinks, Nothing's going to harm me. But that's a very smart and responsible kid; she's not out there causing trouble. She's a straight-A student. One of the bargains we made when she got pregnant was that she would stay in school and go to college after that. I will stay and take care of the baby as long as she needs me. I love that baby, and her great-grandma loves that baby more than life. She'd rather be with that baby more than anything, which is the way it should be.

Felicita Ames
Mother student
17

I have a very good relationship with my mother. She's almost like a friend, but she keeps the relationship so you still know she's a mother. When we found out I was pregnant, she stood behind me all the way. She told me that we were going to keep the baby, and that I had to promise her to finish school, which I was going to do regardless. I'm in my last year now. My mother is a very kind person.

My grandmother is a very kind woman also. She more or less raised me for the first ten years of my life because my mother was an alcoholic. My mother was there at times, but then at others, she would just take off and my grandmother was the one who was there. Because she did raise me, she loves me a lot, and I love her a lot too. She's provided me with my life and whatever I needed.

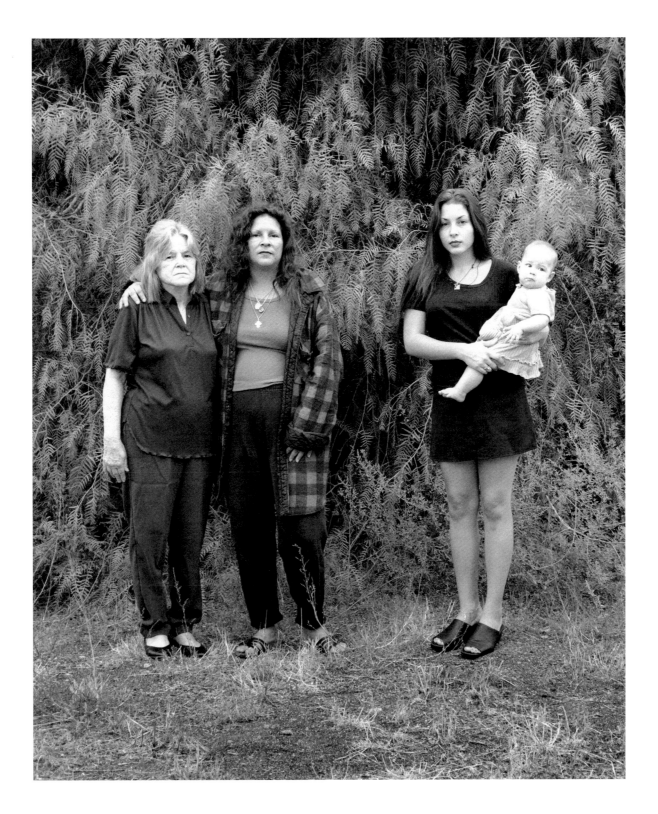

Leah Posner

Grandmother restaurateur

74

Leah Posner. That's the name I was born with. I'm the person I started off being; I just got older. My mother and I slept in the same bed until I got married, close like spoons. There was a money problem, like we had none. We had a two-bedroom apartment, and I could not share a room with my brother because we were beyond that age, so my brother and my father bachelored in the two-bed room and my mother and I snuggled together. Any psychiatrist would probably be roiling in space but I was loved and I know the great security I've always felt. I'm so comfortable inside my soul.

My mother was American born, which was unheard of in my generation. She was born in Cincinnati in 1881. I was so proud of my mother. She had a college education, just short of a degree, and a beautiful, cultured voice.

Only one time my mother, whom I was very proud of, embarrassed me so, and a whole philosophy came out of this particular day. I was meeting her in downtown Cincinnati and I was with a couple of my friends who had much more money. I met my mother and she had two big runs in her stockings. It was a rainy day and her dress was shabby. It was clean, but it had been black and it had this shine of an old dress from wear. Her shoe heels were run over. I hissed at her quietly, "I'm so ashamed of you." My mother said, "OK. That will be the last time you'll ever be ashamed of me. From now on, if there's anything to be bought, a new dress, a new pair of shoes, I will get it first and you will get it second." I said, "That's exactly what I want." I needed my Mom to show this world how great she was. That experience gave me a sense of taking care of yourself first. You don't self-sacrifice for children. It's pitiful, this "Look what I've done for you all my life" syndrome. Take care of yourself and your own pride. Your kids will be fine. They're young. They'll look good in stockings with runs in them. They'll start a trend.

I talk to Susie and Nancy every day on the phone. We're real female. We're not deep and academic. We talk about food and about clothes and about guess what somebody said to us. The depth is that we share our lives hourly. It's so full of light. Our relationships are not hidden and analyzable. The very intimate closeness I had with my mother, I have with my kids. We breathe each other's air.

I'm a better grandparent now that my grandchildren are growing up. I'm not good with little kids. Everything that I'm composed of, I used up already on my own children. The real excitement is watching my children who own me and I own them deal with their children. I love the anecdotes. Part of my day is when Susie and Nancy report how one of their children has handled something. It's fun to be one seat away and not be in charge. I love watching my kids squirm and handle it. I can sit back. My connection, and it's a very deep one, is through watching my daughters be mommies and watching my son be a daddy. That's where my connection to my grandchildren really is.

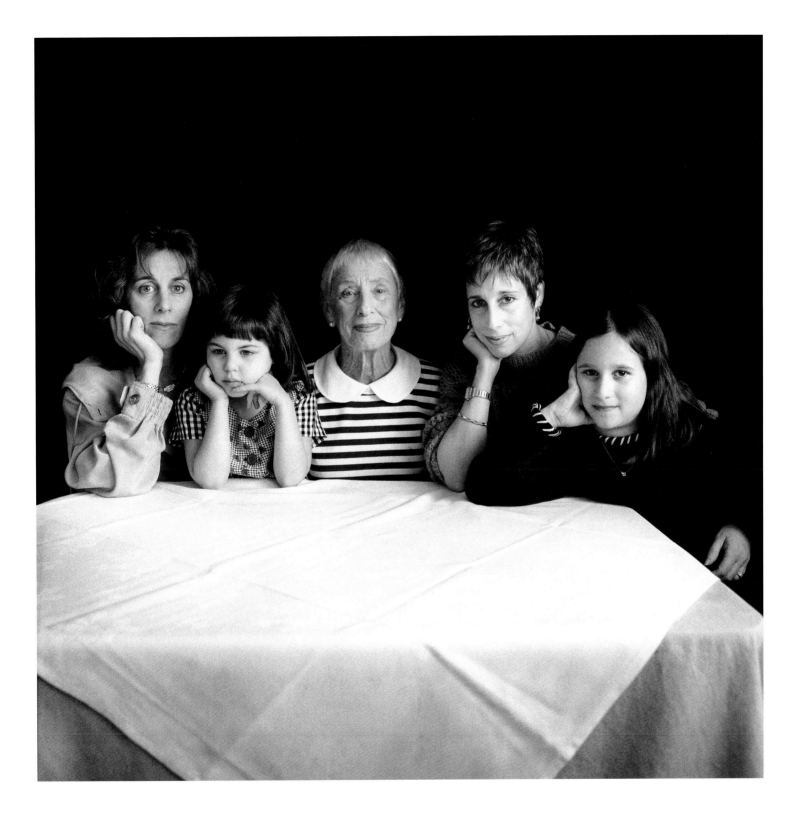

Dionis Coffin Riggs
Grandmother poet
98

My mother was born in the house I live in now, where I lived with my grandfather, a whaling captain, for many years of my childhood. My father died when I was quite young and my mother worked in New York, leaving me with my grandparents and my aunt. My aunt Alvida thought I was her child and I could do no wrong.

In the days of my childhood, when the men were going to sea, the women were very important on the island. They pretty much ran things. The men aren't at sea now, so the women are cooperative with the men whenever necessary, but they aren't the boss anymore.

When I was nine I wrote a poem and rushed to my sisters, "I've written a poem!" They thought it was cute and I realized that they were patronizing me. I decided only poets write poems and I never wrote another one until I was married and won a prize at something that the Women's Club did. I won a dollar prize and that really started me off. I realized I could write poetry. I'm satisfied with life.

Cynthia Riggs
Mother sea captain
65

My mother is an extraordinary person. Here she is at age ninety-eight and I'm not caring for her as much as she cares for me, at least psychologically. She is always supportive, strictly non-judgmental and she's got a wonderful sense of humor. I think what keeps her going to such an advanced age is that she just doesn't want to miss anything. She's scared if she dies, she'll miss something.

My mother was never particularly motherly and I don't think I've ever been particularly motherly to Mary, either. Mary is an incredible woman, a professor of hydrogeology, married with two sons. I feel as if I'm between these two high achievers who are remarkable women and I'd like to be like both of them.

I'm a licensed boat captain. I had a ferry boat business in Washington, crossing the Chesapeake Bay, and I lived on the boat. Everybody in my family's been involved with boats. It seemed as if somebody had to do boats and I'm one of three girls, so I was the one.

Mary Wilder Stoertz
Daughter geology professor
39

My mother has always been supportive of whatever I do. She gave us a lot of room to grow and didn't constrain us. This has its bad sides but I think that in letting us make mistakes and make choices, that helped us grow. With sex, she never forbade us. She said that the world is a smorgasbord of men and you've got to sample them until you find the one that is right. As a result, I didn't. I married the first man I knew well, but I waited until it was right. By giving us freedom, she forced us to make decisions for ourselves.

Grandma was interesting to me as a child, sort of poetic and detached. Then I lived with Grandma for the summer after my grandfather died. In that difficult time I was with her for three or four months. We went skinny dipping by moonlight out at South Beach. She was probably seventy-seven years old and I was seventeen. That time was the beginning of our own relationship. I've always felt close to her, as close as anybody can, because I think she's in another world. She doesn't bare her soul to people. Recently I've started writing poetry. I might have started a long time ago except I felt intimidated and perhaps I kept hearing her voice in my poems. I've broken through that, which also brings me closer to her.

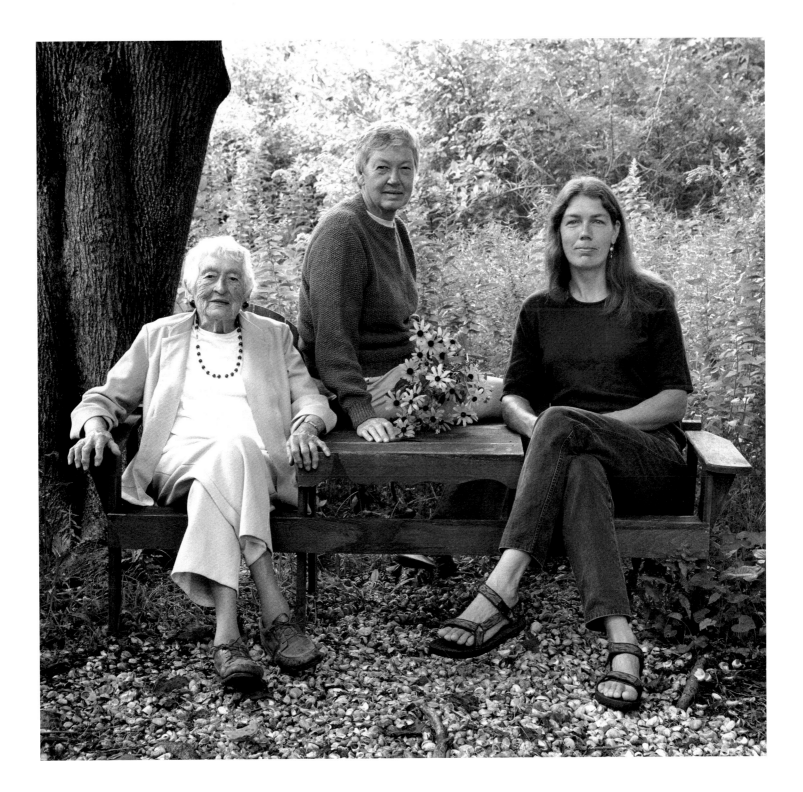

Elizabeth Littleton
Grandmother retired administrative assistant
75

I've lived on this same farm all my life. My mother was my best friend. She was a good mother and always put her family first. We did a lot together. We'd market together, go to church together.

My mother and I thought alike, whereas my daughter's and my ideas are poles apart. We were real close when Elizabeth was young, but then our lives became very different. I've been very close to both my granddaughters because they've lived with me quite a bit during their lifetime. Sometimes they're more like my daughters than my granddaughters. Elizabeth moved around a lot, in and out of marriages. She told me it took her a long time to get it right. It was hard on the girls, changing all the time. When my husband died, I don't know what I would have done without my granddaughters. They were my mainstay. Sally and I are most alike. We're strictly country.

Times have changed but not always for the better. Families used to be closer and did more things together, because people used to live near each other and didn't have so many outside attractions. In this generation, everybody goes a different way.

Elizabeth Schaaf
Mother archivist
55

When I was a child, my mother and I were headstrong and stubborn people and got along just the way you would expect two stubborn and headstrong people would get along. Mother was the can-do woman everybody always called on to do everything when something needed to be done. I was the bad girl, getting into trouble, driving both my parents to total distraction. My mother would cope with this by pursing her lips, rolling her eyes heavenward, and then completely losing her temper.

My daughters are, not surprisingly, headstrong and stubborn. They have very definite minds of their own. As three generations of opinionated women who sometimes have a tempestuous relationship, one thing I've always thought was nice is that whenever there's trouble, the wagons circle. There's never a second's hesitation; each of us will step in immediately and do whatever needs to be done.

Jennifer Morgan
Daughter curator
36

My grandmother's the mother of the group. My mother tended to be in the elder sibling category because we lived with my grandmother for a while. My grandmother's the one who's had the same address and phone number forever, so she's the anchor and the matriarch. She put me through college. She's pragmatic and extremely generous. She's been "Granny" since she was thirty-nine years old. I have a lot of respect for her and what I like about her is the continuity she represents. I went to thirteen schools by the time I graduated from high school. Mom was always doing really interesting things, but I just wanted to be in one place. My grandmother was always in the one place.

My mother and sister are very similar in personality. They're a little moody. I used to spend a lot more time with my mother when she was a single person. She's only twenty years older than I am. My sister is turning out to be a lot like my grandmother, bound to the farm. My mother and I live downtown and go to lots of events, but I think we're all similar in that we're interested in the family.

Sallyellen Hurst
Daughter farm owner and veterinary assistant
32

My grandmother and I are really close. I wouldn't have the house and the farm without her. This is all part of her property and it means a lot to her to have somebody in her family own part of it. She and my mother are very different people. Granny's very conventional, traditional, and conservative and my mother's on the liberal end of things.

I never considered having kids. I'm allergic to children. There are some people who are really cut out to be good parents. It will probably be better if I don't have children.

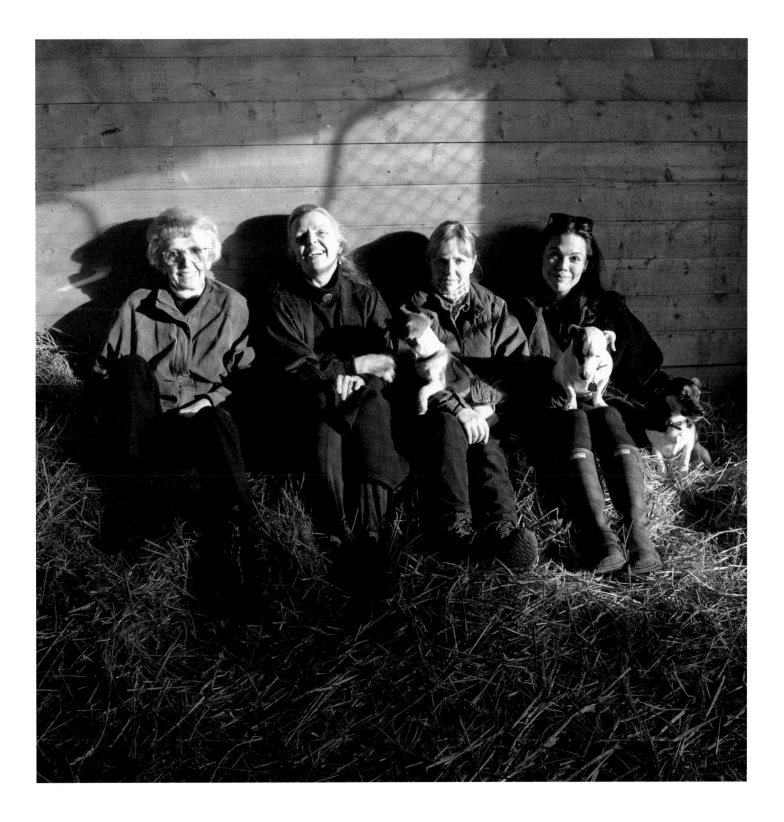

Ruth Ressmeyer

Grandmother deacon
72

My mother grew up on a farm in Wisconsin. After my mother died, I learned that she had played the organ in church, but when we were children we never knew that she played. She was a very dear person, very self-effacing. I see her in our daughters, too.

I learned from my mother to carry my burden as a wife and a mother and not complain about it. I'm a feminist and yet I'm not. As a child when I saw my father in the pulpit, I just wanted to be a minister. I knew from a very early age that it could not happen in my generation, but I wrote a bible study about freeing women to be clergy. My daughter, Vicki, fulfilled that dream for me, but it was not at my instigation. I myself took two years of training in theological subjects to become a certified roster deacon in the Evangelical Lutheran Church in America.

Victoria Sirota

Mother episcopal priest
47

I've only really gotten to know who my mother is since I figured out in the last ten years who I am. I had been a musician my whole life, and my mother played the piano by ear and sang, so the interest in music was where we connected. I also knew when I went off to college that she had some very profound spiritual experiences and that something was sort of shifting.

Ten years ago I was an organist and choir director at a church, but then I had a profound spiritual experience and it turned my life upside-down. I realized I felt called to ordination, which was still impossible in the church I was raised in, Missouri Synod Lutheran, which is a very conservative branch of Lutheranism. Not only is my father a Lutheran minister, but so were my grandfathers on both sides, and my great-grandfather was one of the founders of Missouri Synod Lutheranism. I struggled a lot with the presence of God in my life, not realizing that when people talked about getting called to the ministry, it wasn't that they just decided to do it, it was as though God had shown the path.

Then I thought to myself, "You can't want to be a priest," and that was upsetting to me because I became aware of how the sexism that I had experienced in my life has seeped into my own soul. The fact that I couldn't be a priest as a young girl had made me think that I didn't want to be one. My process in the last ten years has been coming to terms with my female side and beginning to understand God's presence in me, a female spiritual presence. My mother was realizing her own spiritual side at the same time and so I have begun to realize we share a spiritual side as well as music, and as a result my relationship with her grows stronger.

Nadia has got a lot of soul, a profundity. I'm unworthy to be her mother. She's really strong. She's the kind of child who even as an infant would look at you and just know when you needed calming down. It is wonderful and scary when a child knows you better than you know yourself. Nadia is a very competent musician and all the musicians in our family start with singing. That's the tradition of my family. My mother took voice lessons and sang solos in church, and Nadia is singing the Mozart *Requiem* and the *Carmina Burana*. For a musician that is a fabulous education. She took violin lessons when she was younger and now she is a violist.

Nadia Sirota

Daughter
14

My mom and I have a surprisingly good relationship. I feel like I can talk to my mom, not about everything, but about a lot of things. I always tell everybody that she had a midlife crisis and became a priest. She is strong, nice, and kind. She is funny. She's a very easy person to like. There's no struggle there.

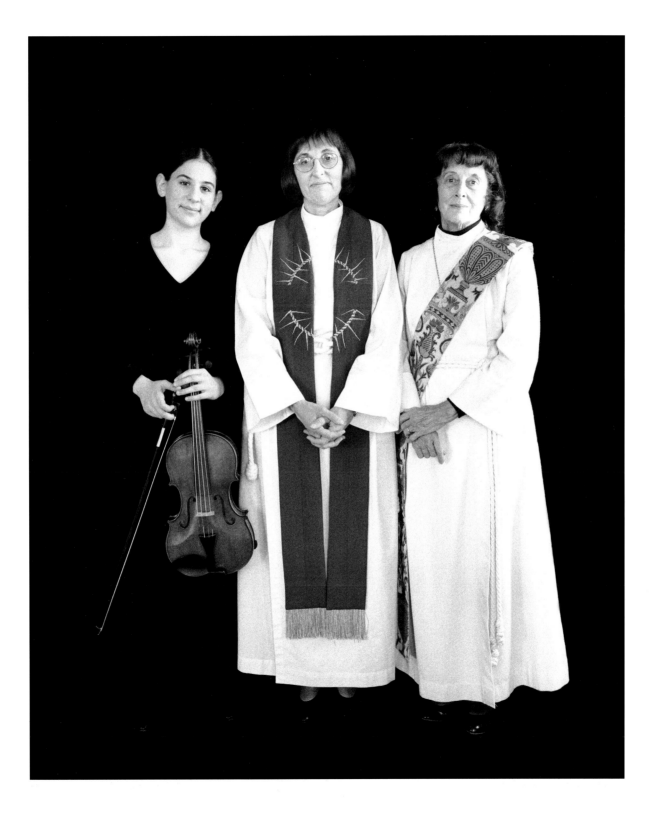

Nora Stone Smith
Grandmother permanent student
67

My mother and I were close, but it took a long time to get there. She believed in a kind of big-family hospitality and we were always ready to try and help out a relative, not just a sibling. We had something like twenty-one first cousins and everybody was always putting each other up. One of the hardships of her life was that although her family didn't have any money, there was always going to be something for the two boys to go to college, but not for her. She was much the brightest in the family. I went back to college when I was in my fifties and so my mother, Tappy, started taking courses in philosophy; she was in her seventies.

It was not the easiest way to start, but she got on the subway and went to school with her little tape recorder.

My granddaughter, Katie, won't have the problem of being a woman or girl who is bright and isn't going to get somewhere with it. She is independent and intelligent, and is not afraid of that at all.

Temple is always the person I pick up the phone to call when I get back from a trip or when she's going somewhere. I like to keep in touch with her. We had hard times when she was in her late teens and early twenties, but we keep in touch and I feel great with her now.

Temple Smith Richardson
Mother magazine editor
40

My relationship with my mother is improving because I have a daughter. We have had a lot of stress and tension over the years, and a lot of my feeling she was telling me what to do and her feeling that I wasn't listening, both of which are probably true. Now that I am a mother, I'm trying to do some things differently.

Katie gives my mother and me a nice common ground. Katie is an extraordinary person. Everybody says that about their children and so I'm glad I can say it, too. My husband and I have turned out to be quite

natural parents, and because I can be a full-time mom I can really get into it. We're learning a lot more about ourselves and about each other. Neither of us have expectations of her. I don't have any ideas like someday she is going to be the president or someday she is going to be a stewardess. I believe strongly that kids just come out who they are. Your job as a parent is to help them find their path and follow that path; not to lead them to it, but to take the obstacles out of the way. I find it fascinating.

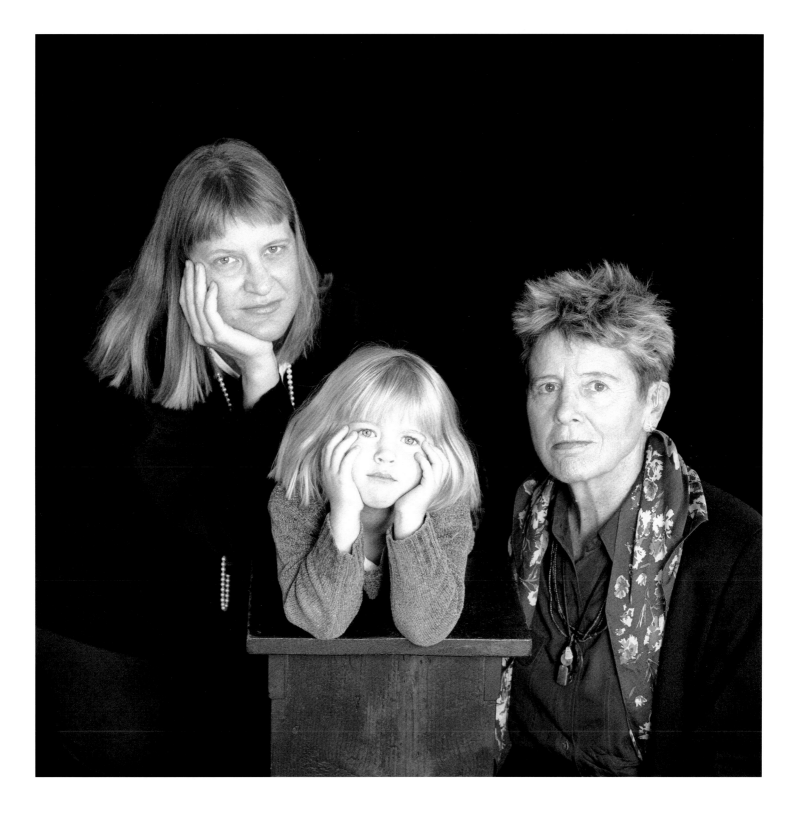

Selma Burgunder

Great-grandmother retired volunteer

I don't know how old I am. I'd have to ask my mother, and she's not here any more. The advice I would give my great-grandchildren is to love each other.

Rose Styron

Grandmother poet and human rights activist
AGELESS

My mother and I have always been very good friends. I admired her very much. She was very social and always looked beautiful. She had gorgeous clothes and what I liked best when I was little was helping her pack to go to Europe with my father. They had wonderful big, old steamer trunks and I got to fold all these beautiful chiffon and silk dresses.

Because I was the youngest, my parents would take my brother and sister on trips to Europe or across the country and I was left home and would stay with a favorite aunt. I spent every summer with my grandmother. I was the little princess with her and her sisters, who were all widowed by that time. I had a very free life there, unlike my life at home. There'd been the Lindbergh kidnapping when I was a baby, so my parents made sure they never left me alone. I always felt overprotected by the loving people who were around me and I spent all my time trying to escape them.

My mother was a suffragette before I was born. I remember seeing picures of her and her telling me about how important it was to get the women's vote and how important it was to be an activist and to do what you wanted to in life and to fight for what you believed in. That was quite an influence on me.

When I was growing up, the generations were very separate and there was always help to take care of us. I never felt that I was intimate with my mother in any way and I always assumed her life and my father's life were perfect. Nothing was ever talked about in my presence that wasn't pleasant or that was personally revealing. You just didn't do that with your children. With my kids, it's very different because I've brought them up. We're very close, they know all our emotional triumphs and disasters. It's a big difference, but it's the same kind of loving family wanting the best for everybody in the family.

Susanna Styron

Mother film director and screenwriter
41

My relationship with my mother is great, really close. In that way the relationship I have with my daughters is similar. She is very different from me as a mother, much more easy going and indulgent. I am stricter and more of a disciplinarian.

I've always been very close to my grandmother. I see her as often as I can. I've always felt we had a special rapport. In some ways, oddly, I'm probably more similar to her than I am to my own mother. We're both a little more opinionated, a little less flexible, a little more stuck in our ways. Maybe it skips a generation.

I want my daughters to be able to be the best and the most of who they want to be, to be able to achieve what they strive to achieve in their lives. And not to do it selfishly, always to take the rest of the world into account, which I think they do. It's a very important thing in their upbringing, to always consider other people.

We are a particularly strong, powerful, and willful group of women. There is a predominance of females in our line and I like the female energy in our houses. I always wanted daughters. It does good things in the world to have a lot of females around.

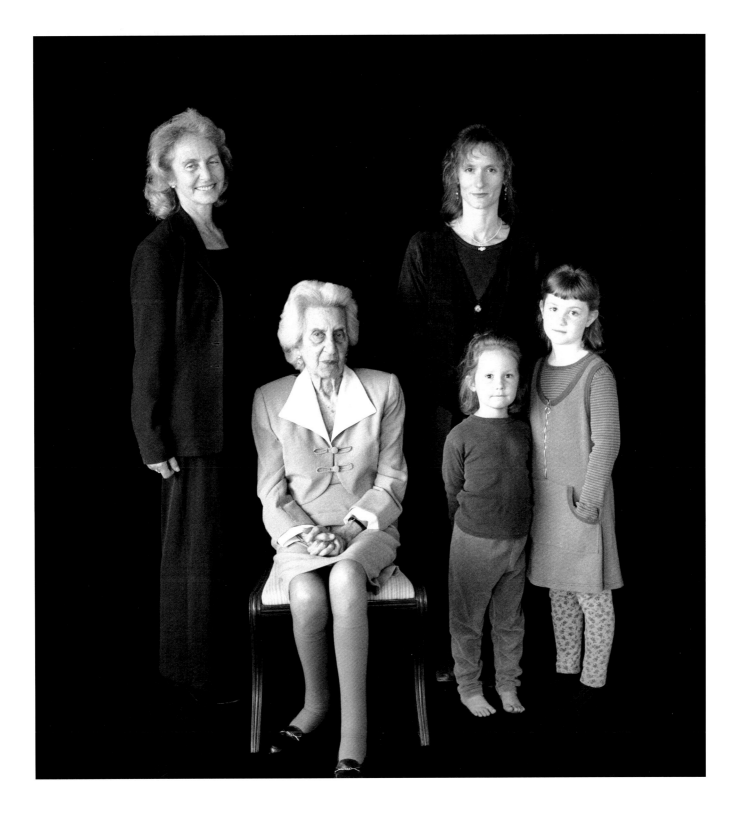

Mary Travers

Grandmother singer and songwriter
56

We're living in a time when women have a choice as to when they want to have a baby. I see the attractiveness of having one later, but I also see the practicality of having them earlier. When you're younger, you have so little structured life to interrupt. You haven't really forged a direction, so a child at that point can be encompassed into your life as it's rolling along. If you're older and you have a career, then you have to make arrangements and try to get the baby to fit into an existing pattern and that's always much harder.

I was raised by women who believed that women were supposed to work. My mother began working when she was seventeen as a cub reporter and she brought me up to believe women worked and that women could work and raise families.

I was raised by my mother and a housekeeper. The housekeeper was a marvelous woman whose name was Lilah; she was black, originally from Virginia. She was forty when she came to work for my mother. Between the two women, I got a superior mother. They both loved books so I loved books. Lilah had a much better sense of humor and a great imagination. My mother was a little more on the edge in terms of trying to keep all the balls in the air. She was very bright and had a tremendous sense of both personal ethics and ethics in the big picture. She was very involved in the formation of unions.

My mother had to move into a home a few years after this picture was taken. It's crushing because I'm seeing the part of her go that was her pride and joy: her wit, her experience, her take on books. When I wrote something, I would take it to her and grit my teeth while she edited it to death. It is tragic to see her go like this.

The relationship I have with my daughters is very different from the one I had with my mother. My mother was orphaned when she was five and raised by her grandmother. She was never a touchy-feely person, so of course I'm a very touchy-feely person. My daughters are touchy-feely and they're very close. Alicia is moving to Greenwich, where Erika lives. That's nice because one always wants one's children to like each other.

If there's a social wave coming, I have a feeling it will be manifested in the reinvention of the family. I see it already in the fact that children don't leave home. Part of that is economic, but I think it's more than that. We are approaching the twenty-first century with technology racing ahead and the social animal is adrift in it and desperately trying to find some bottom line that proclaims his or her humanity. People on the Internet think that this is a big explosion of intimacy in the new world, but it's not intimacy. Intimacy is always going to have to be about touching, about looking into someone else's eyes, about seeing tears and knowing that tears are salty, not reading about them.

As a parent, you want your children to get on with it. The sooner young people can jump in and bite life on the ass, the better.

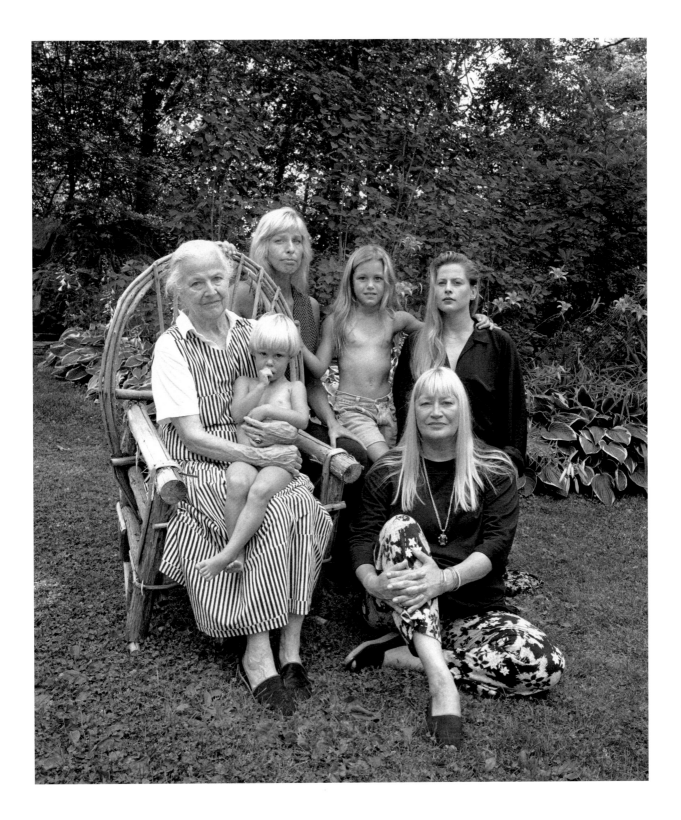

Anne Truitt
Grandmother artist
76

I learned a sense of structure from my mother. I learned how to maintain dignity, how not to lose my head under circumstances that are upsetting. I learned to maintain a stiff upper lip. I learned to forgive and to be forgiven. I learned how to move over into a fresh place.

My mother's mother, the lady in the portrait, was in the first graduating class at Smith College. My mother went to Radcliffe. They were badly criticized for going to college; it's a long line of blue stockings. I learned a great deal from my mother about reading because she read to us every night and she began to read to me when I was six or seven. She started me on poetry, on *Jane Eyre*, on Jane Austen.

I also learned independence from my mother. She went to France as a Red Cross nurse during the First World War. She'd been used to going to France every summer with her mother so she had some experience with it, but nonetheless when the United States entered the war, she got on a ship and went to France. I think that takes nerve.

Both my daughters are loving and generous. They're very able to forgive, to turn over new leaves and start fresh. They have what the eighteenth century called bottom, meaning the ability to persist and to persevere. It's a very compatible, chatty family. My husband used to say we were like a cage of birds, always talking.

Alexandra Truitt
Mother photography editor
41

My mother's life has been a life of integrity, dignity, and hard work. Those are qualities about my mother I've tried to have in my own way. I've copied them from her, but I don't know if I've learned them. I think I get more and more like her as I get older.

Mary Truitt Hill
Mother writer
38

The most useful thing I've learned from my mother is a balanced way of looking at things; to look at the physicality of things, the overall spirituality, the way things play themselves out, and not to act too quickly. It is a measured look at things. One time when my life was insane and the world kept going faster and faster and faster, we went to the beach together for a few days. I said to her, "I'll be fine if the chaos will end for just three days." She started to laugh and said, "Oh, Mary, the chaos is never going to end. The only peace there is is the peace with which you greet the chaos." That changed my life completely.

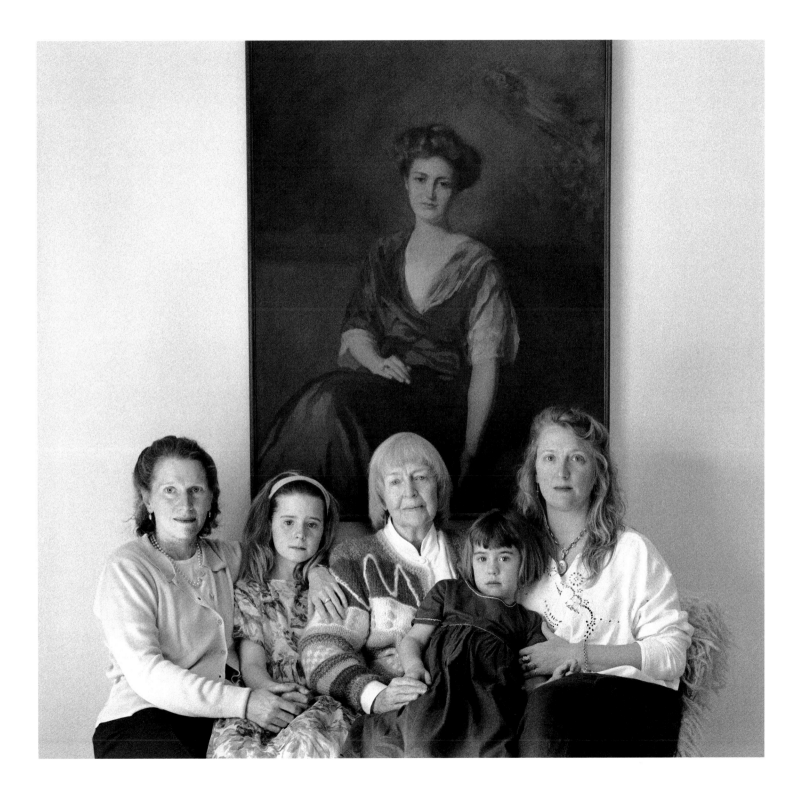

Maria Versace
Grandmother housewife
60

My five daughters are very nice to me. They respect me and I respect them. God helped me to help my kids. It was a little hard when the girls were small. I got up early in the morning, around five o'clock, to keep my house and my kids clean and to cook. At night I stayed up late doing washing to prepare for the next day, because I had to send them to school. Now, I help take care of my granddaughters. They like to stay with me and I make breakfast, watch that the girls' bath is fine, and send Alyssia to school. After school I prepare a little bit for them to eat.

Alyssia is very, very nice and she's smart. She says she's going to help me when I'm older. I don't give her a hard time and she listens to me.

Every morning the girls call me and say, "Ma, what are you cooking today?" Sometimes they ask if they can come for lunch. I make lasagna, cutlets, roasts, vegetables, potatoes, a lot of things. I have at least eight people for dinner every night. The phone rings constantly.

I cook for everybody. When I die, who is going to come to this door? Nobody. It's OK. I feel good.

Anna Morena
Mother administrative assistant
33

I've been very close to my mother since the day I got married. She always comes with us, whether it's driving, going out to a restaurant, or even shopping. I have dinner here with my kids every night. I sometimes say that I'm not similar to her, but I am. For instance, when Mom cooks she likes to be left alone in the kitchen. I'm like her. And when she's not cooking, she always wants company. She doesn't like to be left alone at home.

I'm very close to my daughters, as if they're friends. From the day Alyssia was born, she went everywhere with us. She always wants me around her. The minute I set foot in the door at work, the phone rings and it's Alyssia. She wants to make sure I got there. They're used to it at the office. And when she comes home from school, she calls me. In family life I'm involved with women mostly. Until the children are at a stable age, I'll remain as is.

I was thirty-one when my husband died in an accident, a drive-by shooting, in Italy at Christmastime. We were all in the car, my daughter and I were in the back seat. My husband died with his mother. Life goes on. I became a stronger person.

Alyssia Morena
Daughter
6

I love my mom very much, a lot, a lot, a lot. My grandmother takes care of me and I help her make food and lunch. Nona always says to me, "Get ready, get ready." Sometimes I sleep next door in my own house, but sometimes I sleep at my grandma's because I love my grandma, and the bus usually comes by here and not by my own house.

My grandma bought me white shoes the day after I got my report card. She spoils me lots and lots and lots of times. Sometimes I go to bed late because I have so much fun staying up.

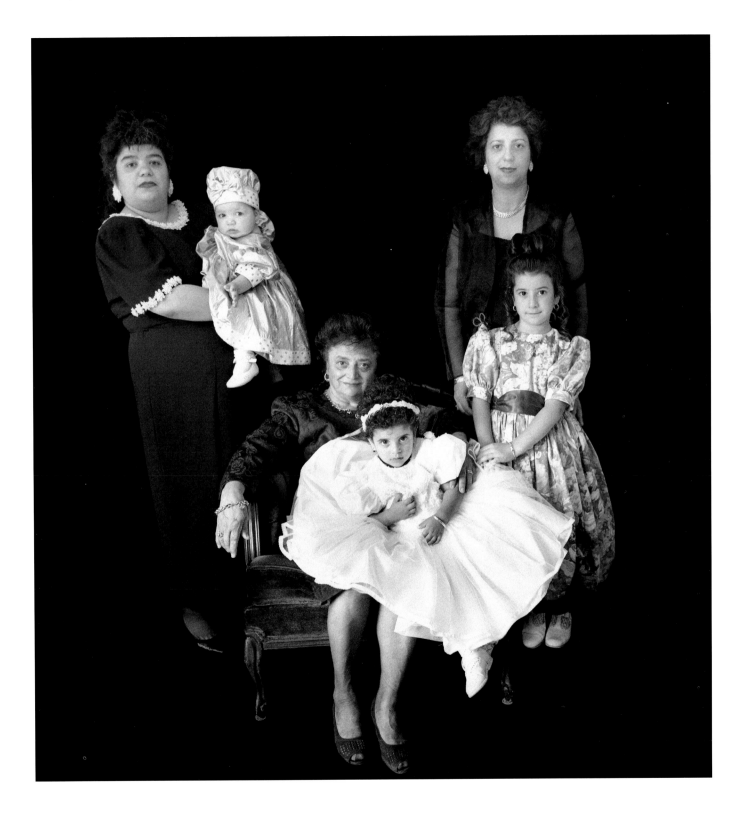

Elizabeth Winthrop
Mother writer
48

I often think of myself as the synapse between my mother and my daughter, the contact point at which their impulses are transmitted from one to the other.

My daughter is twenty-two years old. She has worked in an orphanage in Tijuana, a school in the remote mountain regions of Ecuador, and with Mayan women in the highland villages of Guatemala. She is compassionate, clear eyed, intelligent, courageous.

She reminds me of my mother, who by the age of seventeen had already witnessed the opening battles of the Spanish Civil War and the evacuation of Dunkirk and was working for the Naval Division of the Secret Intelligence Service in London. At eighteen she married my American father and in December of 1944, pregnant with the first of her six children, she crossed the Atlantic on a convoy ship. By twenty-two, my daughter's age, she was pregnant with me, her third child and only girl. When she was forty-eight, my age now, my father died and she reinvented herself. She went back to school and became a medical research technologist. My mother is smart, direct, engaged in life, and uncomplaining.

Their energy courses through me. I provide the bridge. I serve as archivist and witness. I tell the stories.

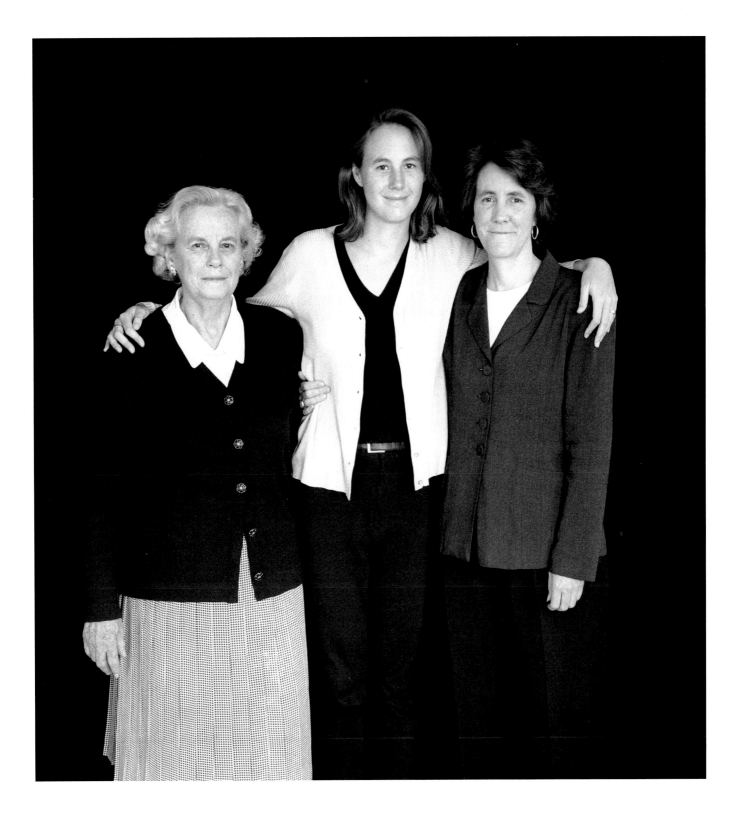

Barbara Wright

Great-grandmother nursing assistant
65

I had Cheryl when I was seventeen years old. My second daughter was born fourteen years later, my third two years after that, and two years after that my granddaughter, Kristin was born to Cheryl. My two grandchildren have an enormous age spread, twenty-four years. Kristin has three children, so I have three great-grandchildren who are older than my second grandchild. It's very confusing.

We are such products of our parents that when my mother would tell me something, it would be something that her mother had told her. Cheryl says she can hear me when she opens her mouth. It's strange how many generations are involved in what you tell your children, without your even realizing it.

Cheryl and I had the usual mother and daughter problems as she was growing up. The teenage years were tough, she always thought she knew more than I did. You get upset at first and then you stop and realize you did the same things and put your own mother through it. And Kristin does the same to Cheryl. It'll always be there. I'm sure it's the same way with sons and fathers, too. There's always competition.

Life is different than it used to be, especially for women. Men still go to a job and come home and relax unless they cut the grass on the weekend. Women go to work, come home, take care of the children, do the housework, and do all the other things, too. Women don't stop until they get into bed. There are trade-offs: I don't have to wash clothes by hand and I don't have to make my own bread; I go out and work and buy bread at the store on the way home, and I drop off the laundry.

Cheryl Forden

Grandmother utility worker
48

My mother was very young when I was born. It was just the two of us for a long time. That's similar to my daughter and me because she and I were alone together for quite a while. I was only eighteen when Kristin was born. There are a lot of similarities between the two relationships.

I've been working all my life. My mother's still working. We hope it will be easier for Kaitlin. Education is the key. I drive a forklift for the electric company. It's great; it's good money. When I started in the company they were looking to put women in nontraditional roles and I took advantage of it. I don't regret it. I'm the only woman in my department. In the beginning I felt I had to prove myself, but they've accepted me. It's a different world; women relate differently to each other than men relate to men.

Kristin Bove

Mother lifeguard
29

My mother and I are totally different as parents. I'm a lot wiser than my mother was; she treated me like a little doll and then more like a friend. That was a problem because she didn't enforce rules and discipline. I was basically a good kid, but when she needed to put her foot down she didn't. She was a great mother otherwise. I'm not going to make the same mistakes with my daughter that my mother made with me. Children have to own their bad behavior and not be rescued all the time. My mother felt that if I was unhappy, it was her job to make me happy. She didn't let me find the answers myself. As an adult, it was really hard for me to take responsibility for myself. I'd always had my mother to fix it. I'm right on Kaitlin all the time. I don't want her to make the same mistakes I made, going out on my own and having children so early, growing up too fast. I won't allow her to do that. I won't.

Kaitlin Bove

Daughter student
11

My mom and I like to do things together. She's wicked nice. She's always there for me and when I need help with something, she helps me. When I want to have fun, she has fun with me. We argue sometimes but we always make up.

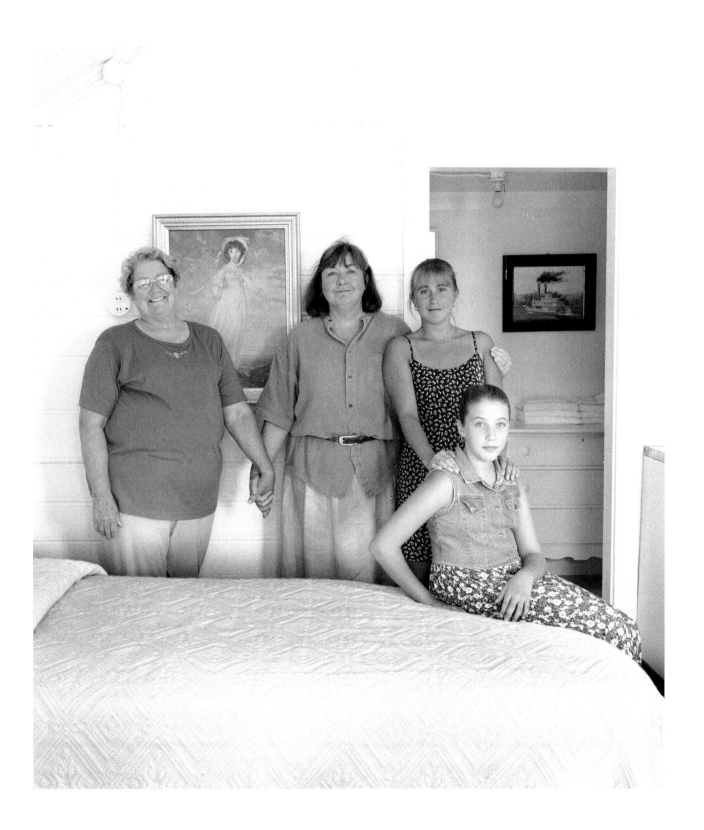

Janet Fisher
Grandmother volunteer
80

My birth mother died when I was three years old and my father married my mother's sister, who became my surrogate mother. She was a wonderful substitute, but I always hankered to know what life would have been like with my real mother.

Nancy was my middle child, a difficult position when there are three in the family as I well know, having been in the same position myself. Nancy was always tender and loving and considerate of others and would never hurt a flea.

I worried about Nancy during her adolescence, but she has been a great supporter of me in my trials throughout my life, both medically and after I was widowed. She has turned out to be a spectacular leader, and in addition to raising a lovely family, she started an organization called SCAN (Suspect Child Abuse and Neglect). One could not ask for a better daughter.

Nancy Fisher
Mother rug hooker, volunteer
52

I don't know if I learned anything from my mother, but I absorbed. My mother was a very hands-on mother who spent a lot of time with me. I remember how I used to hide behind my mother's beaver coat. As an adolescent, I followed what my mother said. Those were different times, and I don't recall fighting with my mother as much as I do with Diana. I'm spending my adult life helping others and Diana has those compassionate genes in her. She is very considerate of others and very loving.

Diana Kirschner
Daughter student
12

I don't think my mother and I are as close as most other moms and daughters because she's not home very much and she's favored my brother more. When I was little I would cry hysterically if I was separated from her, even if we were in the same house. I just always had to be looking at her, and then at night I would always have to sleep in her room. Over the years I became more independent from her, and the past summers I've been going away to camp and I barely miss her at all.

When she's home, she's just not available. We barely talk. If I had a daughter, I'd have a different kind of relationship with her. Sometimes my mom has the worst attitude and I always tell myself I'll never be like that.

I think I have my dad's personality, but I never see him. He lives with us, but he's a lawyer and he's out before I leave for school and sometimes comes home at eight o'clock. He's a golfer, so on the weekends he goes out golfing. It doesn't bother me.

I love my grandmother the most. I can relate to her more. She's caring and generous, and she's just always there. I'm more similar to my grandmother than I am to my mom.

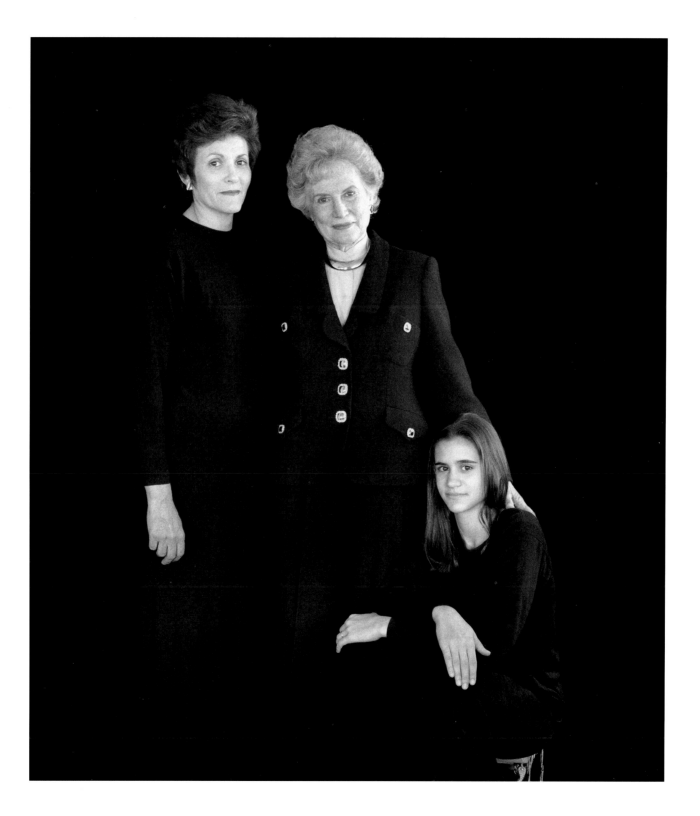

Virginia Adams
Great-grandmother avid reader
92

What is one's relationship with a mother? I don't know. I was very fond of my mother. I don't understand modern words like relationship and interaction; the way people use words is different from the world I knew. We were a loving family; we all enjoyed each other.

Anne Adams Helms
Grandmother retired businesswoman
61

My mother and I were such good companions in my teenage years. We worked together all day in the shop in Yosemite during the summers when I was home from school. We went to the southwest on buying trips for Indian jewelry, and we were just really good buddies. I would go back to school and hear girls brag about how they told off their mothers, and it was incomprehensible to me that you would talk that way to somebody you liked so much.

My three girls and I have a good relationship. I don't know that the teenage years were so companionable, because their father died when they were quite little and I remarried and was working. Now when we get together we have the best time. I was asking the girls what they thought had come down through the generations. They said, "Oh, being a hostess!" We all learned to be polite, to entertain, and to love reading.

Virginia Mayhew
Daughter jazz saxophonist
37

I've been thinking about what I have learned from my mother and grandmother. Just about all my values come from them: hard work, the strength of family, appreciation of a flower and a sunset, and of quality in everything. They have taught me to do the right thing, to be polite, and to enjoy reading. Both my mother and my grandmother have tremendous inner strength.

Alison Jaques
Mother publisher
35

Growing up, my mother raised the three of us herself. She was very busy working and taking care of our home, so we weren't really close then. When I grew up we learned how to talk to each other, and when we started working together we became very good friends. I've learned everything from her, mainly caring for people, hard work, and independence. We watched our mother do everything on her own and learned that we can do whatever we want to do.

I hope my daughter will follow in my footsteps and take over the Ansel Adams photograph reproduction and card business that my grandfather Ansel started. My mom ran it for twenty-five years and I've had it for ten.

Sylvia Desin
Mother quilter
33

My relationship with my mother has always been easy. I was the only girl in my whole class who liked her mom in adolescence. Everything I enjoy comes from her. We love to throw parties, have lots of people over. And reading; I forget that there are people who don't like to read because I read all the time.

I lived with my grandmother the summer I graduated from college and that was quite an experience. I get teary thinking about her; she's getting so tired. She's ninety-two and she has a right to be tired.

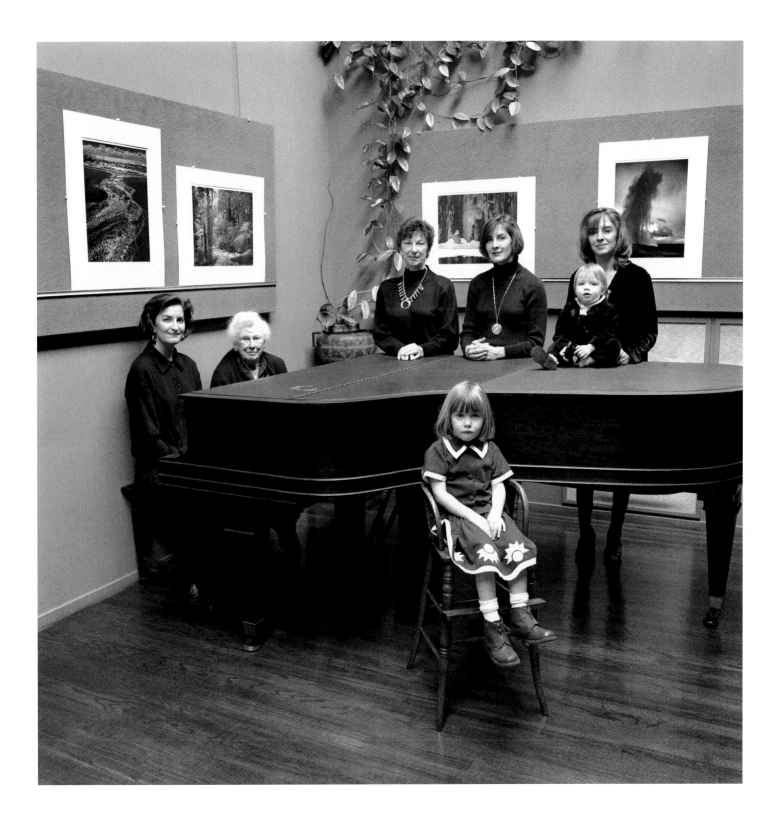

Elizabeth Longford
Grandmother writer
90

My mother came from a very large family in the city of Birmingham, England, and her father's brother was a famous liberal statesman who became a radical, Joe Chamberlain, and her first cousin was a prime minister of England, Neville Chamberlain. There were seven daughters in this family, and two boys only at the end, so she really grew up in a female society, except for her father. She was trained as a physician, which was quite rare in those days. And then she met her husband, my father, who was also a doctor in hospital and they married. She had just begun practicing in hospital, but after she married she devoted herself to her five children. My mother was always a buffer between the children and our father, who was a very old-fashioned, rather tyrannical, dogmatic, very clever man.

I have sons as well as daughters. I am very close to them, I love being with them and talking to them, but I don't depend on them in the way I depend on my daughters. I just can't imagine life without daughters, whereas I could endure it without sons. That's only a way of emphasizing how important daughters are. Every time a son was born I was tremendously excited, rather more so than when a daughter was born, and then as they grew up it turned the other way round. It's the sisterhood of women. Women feel responsible for each other. If I asked one of my sons to drive me to the country or buy me some flowers, they would do it, they'd be delighted. But they wouldn't sort of worry about any particular aspect of my life, whereas my daughters would worry about my life and I would worry about theirs.

I write biographies. Nearly all my books have been biographies. I began seriously as a writer after my youngest son had started going to school. Very soon they were all away until tea-time, so I would do my work from nine to four. Then they'd all come back for tea, except for one or two who were in boarding school; then family life would resume, and so it went on.

Rachel Billington
Mother writer
54

In our family, there was this enormous gang of children and then this dazzling wonderful matriarch at the top, so there was never that particular kind of intimacy to fight against. Because my mother is a fantastically energetic and clever woman, she always encouraged all her children equally, sons and daughters, to get out and do things. She wasn't ever a restraining or competitive mother in any way. She was exactly the reverse of all of those things. She was always telling you how wonderful you were and always encouraging you to say yes to everything.

Rose Billington
Daughter literary agent
24

My mother is a writer, and I have always had a sense of what a strange job writing is, compared to most jobs. For Momma, the more normal things I do, like an office job, are incredible. She thinks that to actually get up and out of the house and be in an office by nine o'clock is sort of amazing, because she will stay at home and work in the morning. Tables are turned with us; the kinds of things that most mothers take for granted my mother doesn't, because our way of life is so different. The actual worlds that we move in are very linked up. We both believe in the importance of books and writing and this fundamental agreement makes our relationship much easier.

The same link is there with my grandmother. She's a wonderful matriarch, the head of a family filled with writing and literature. It is strange to see her name crop up in the work that I'm doing, and it's inspiring to see someone with more energy than the rest of us put together.

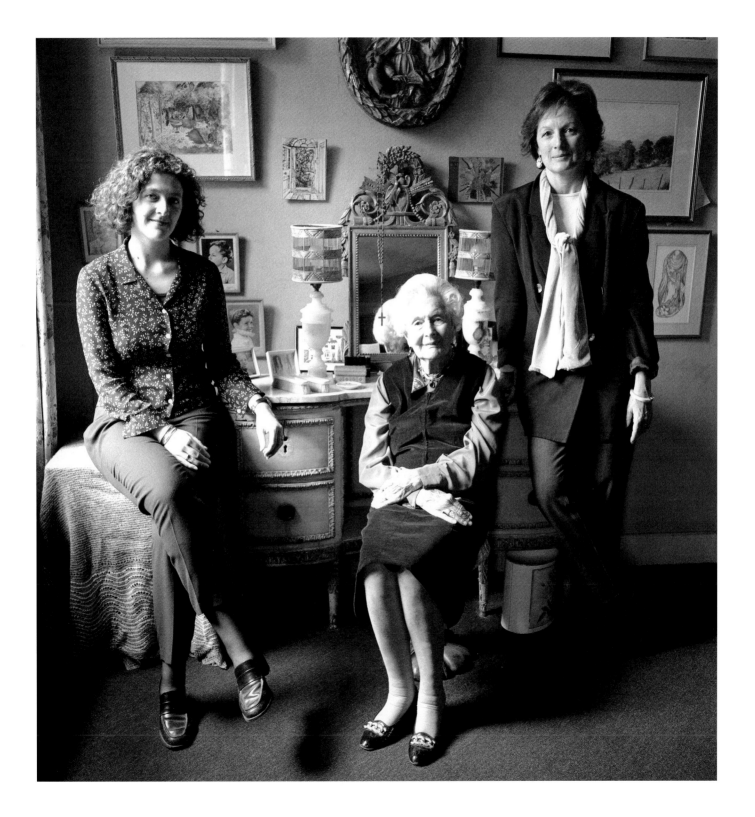

Florence Conrad

Grandmother assistant fire management officer
54

When I was growing up it wasn't cool to be an Indian. We are Karuk and we were more or less forced to abandon all of our beliefs and we weren't allowed by the United States government to speak our language. My aunts and uncles had been taken away and put into government schools to "civilize" them. I don't know why they didn't take me, but they didn't.

My grandmother raised me. Until I was eight, I didn't know that my grandmother wasn't my mother. My grandparents made their living growing gardens, trapping, and goldmining. It was comfortable and loving.

My relationship with my mother was violent and short. My mother was a beautiful woman and very vain and I didn't live up to what she thought her child should be. I wasn't beautiful, and I was very dark. I was the only child she had, and I only lived with her for three years, from age eight through ten.

My daughter Shawnna and I are best friends. She's a wonderful woman, a good mother, an excellent daughter. In the Karuk tribe women do a lot of the menial work, and Shawnna does it well. She's well respected within the tribe with the medicine women and the elders because of her good nature and her willingness to help everybody all the time.

The Karuk Indians have always lived here in northern California, right here at Somes Bar. Where we live is called Cottemein, and I've lived most of my life here. I learned from my grandmother to be strong, and people have said that my daughters are a lot like me. We're strong-willed, which is not a characteristic of the Karuk people, but in this day and age you have to get along in both worlds.

This is the center of the Indian world. This is where it all began, and every year we do a world renewal ceremony to renew our world as we know it. We bring in plenty of food, like fish and acorns. We're gatherers, we're not agricultural at all. We probably have close ties with the Hoopas and the Yuraks, who are downriver. We still have our brush dances, which are healing dances.

Shawnna Conrad

Mother child care provider
26

As far back as I can remember, my mother has always been a friend as well as a mother. Until I was eight, we lived in a two-room house. She knew that she didn't want us to have a childhood like hers, and she was always supportive and never forced us to do anything. We went to school in town and a lot of the kids wouldn't play with us. Mom wouldn't let us be around a lot of people because she didn't want anyone to treat us badly. We'd be together for six months at a time and we'd not see anyone except each other. It was just us entertaining ourselves, and we're still really close.

Aja's father is African-American, but I raise her Indian because that's what I am. She's one of very few African-American kids around. Luckily my father is very well known in the Indian community. He's well respected by other Indian families, so they treat Aja well. Otherwise, they might not have given her a chance. Every now and then something will stick in her mind, like she doesn't like her hair being so curly. Maybe I overdo it, but I always tell her how beautiful she is and tell her the most beautiful thing about her is that she's beautiful inside.

Our culture and our heritage really make us all closer. My mom spent time teaching me to gather stuff for baskets and to gather the local foods that Indians have been eating for so long. That's something I get to teach Aja now. It's nice because it's one of our more defining characteristics, to still have our strong beliefs in the old ways. The hardest thing to teach her is how to be an American Indian in today's world, trying to be traditional and modern at the same time. I think it confuses her now, but I hope she doesn't forget her heritage, her people, and her culture. My father speaks Karuk all the time in our home. We understand it and speak it too, and I teach it to the kids. One of the hardest things to teach Aja is to have respect for her elders and at the same time still speak her mind.

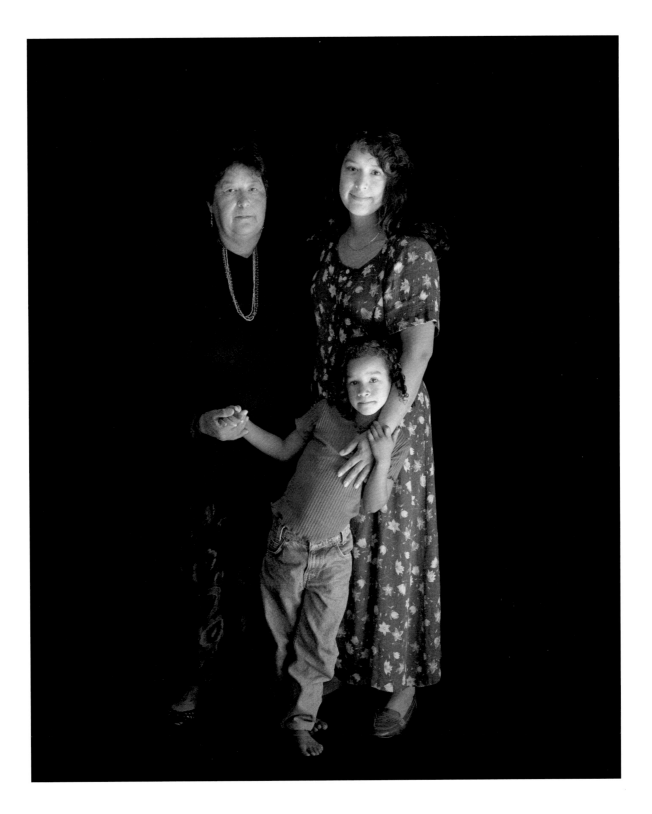

Nancy Heuston
Grandmother school director
54

I've begun to notice how women of my mother's generation had certain things they were assigned to do and they accepted those assignments without anger or hostility even though sometimes the challenge was severe. They would organize their days, their lives, around their children and their family. They are some of the strongest women I've ever known of. When they talk about their family, those are people for whom they sacrificed, never seeing it as a sacrifice but as fulfillment. There is a willingness of my mother's generation of women to accept, to adapt, and accommodate, but never in a spirit of submission. These women are in-dividuals who did not have many avenues open to them. I think that their frustration found outlets, like my mother's beautiful, complicated handwork.

I hope my granddaughter, Jenny, has a sense of history, a sense of gratefulness for the women who have gone before. Each one has lived such a different life. Jenny is a gentle young woman and has a kind, no-nonsense quality about her. I hope she has a sense that her future will be history for those that follow her in her own family. I would like her to value herself as the tapestry in which the threads of all these generations come together.

Kimberley Sorenson
Mother teacher
35

When I was growing up in the seventies, we were in Manhattan. My dad was the head of a school, and because we were Mormon and because there were six children, I always felt very much on display. I was proud of my family, pleased to be part of it, but it also threw into dramatic relief the contributions that my mother made to my life that were absent from my friends' lives, particularly because many of my friends had all kinds of advantages that I hadn't even imagined existed before we moved to New York. We were very fortunate; we got to go to this wonderful school my dad ran, and we lived in a beautiful apartment, but the salary was quite small.

I was very aware of the happy difference that my mother made in our lives. I had a mother who was very talented and capable, but who was interested primarily in being a good mother. I knew that was a sacrifice for her in some ways. She and I would go to foreign films and museums together and talk about the books we read. I was always very grateful for that mothering, and felt that it provided me with a kind of strength and inner serenity and centeredness, a sense of myself that comes only as a result of being afforded a certain level of protection and a certain amount of time, emotional time and space and safety, to really concentrate on growing up. My teaching is really an extension for me of what being a mother meant to me as a kid. It's a way of expressing humanness.

My daughter, Jenny, is not what I expected. Even though I went to a girl's school and grew up with girls in my family, in some ways I am much more comfortable as a mother of boys. Jenny is so much better than I was. She is kinder and smarter, and I feel I don't have the gifts of wisdom and strength to give her that my mother gave me. I do feel, though, it's been delightful.

Jennifer Sorenson
Daughter student
13

I'm really close to my mom. She's like my second best friend. Of course I've got my best friend, but we do lots together, just my mom and I. Everything I don't learn in the classroom I learn from my mother. She helps me know what is appropriate and what isn't, and she directs me into a good way of life. It's nice to be a Mormon, but also it would be nice to be in surroundings where there are other views and other opinions and other ethnic backgrounds. Sometimes Mormons are a little bit sexist. They are a little prejudiced about working and single women and they really stress the family. That's kind of hard because my mom is single.

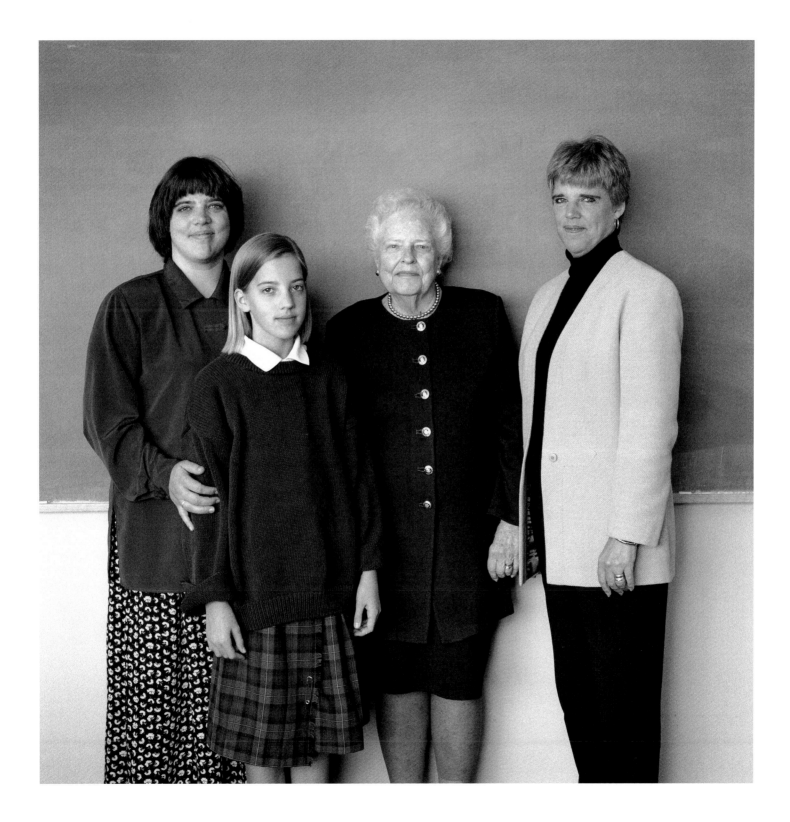

Shi Lun Tien
Grandmother buddhist scholar
83

My father gave me a traditional education. We had a special tutor in the house who taught us history and classical Chinese culture. I graduated from the University of Beijing, one of very few girls who went to college then.

I wept on my wedding day, and my mother was so sad too, because I was going to leave the house and live in another part of China. Twelve days after my wedding, my husband and I moved and I never saw my mother again. Several decades later I tried to get her out of the mainland, but the communist government would not let her go. My husband was a diplomat for the nationalist government, so they were holding my family and my husband's family hostage in order to induce my husband and me to defect. When I was about forty years old I started writing and studying Buddhism seriously, as a comparative philosophy.

Judith and I were more like friends than a mother and a daughter. I never spanked or scolded her if she did something wrong. I would just keep quiet and not talk to her. After two or three days of this silent treatment everything would be OK.

Judith Tien Lau
Mother civic activist
57

Having an exceptional woman as a mother is both a gift and a burden. As a child, I saw my mother as a rather magical creature as she was always busy, rustling off to important events in silks and lace. I would sometimes inadvertently overhear her talking with pride about me to a third party, but very seldom was I complimented on anything. Mother had very high standards, but this is also Chinese—never tempt the attention of the fates and never inflate a child's ego. We also seldom touched except as formalities and I am more comfortable at a distance with her.

My mother is as Chinese as my daughters are Western. I am neither one nor the other. Until I became mature, I could not appreciate having this double vision and felt like an outsider to both worlds. Now I enjoy being on the cusp of both.

Mother gave me a great deal of freedom as I was growing up. She seemed to trust my judgment and character and I never wanted to disappoint or shame her—Chinese are very constrained by shame. I was in my forties before I became my own person and didn't conform my conduct and thinking to what I thought Mother would like.

Laura Lau-Kentis
Mother-to-be filmmaker
33

My mother is one of my best friends; the other is my sister. I feel deep gratitude for what my mother has given me: a ground of love and encouragement that has allowed me to go into the world with a deep sense of comfort in the universe and in myself.

As I am six months pregnant, my mother and I have had many discussions recently about legacy and about identity. I think she is afraid that my baby will lose her Chineseness as my husband is Caucasian. Being exposed to both the West and East has provided me with a kind of vantage point for seeing both the huge differences in thinking and interacting between Chinese and American people, and at the same time, what is universal.

Sometimes I forget how Chinese my mother is. Chinese society has always relegated women to the back seat, so Chinese women have learned to get what they want by indirect means. My mother is very much more subtle and hidden than I am. If I feel something I will come out and say it, while I will have to guess at what is bothering her.

Estelle Lau
Daughter law professor
32

My relationships with both my mother and my grandmother are complicated and a little tortured. I've had a hard time trying to be myself and to gain my mother's approval.

My sister and I are best friends. We talk four or five times a day, from the moment we get up. We'll each be in our own kitchen—I'll be in Buffalo or Los Angeles or Boston and she's basically in New York—and we'll cook dinner together. I don't think there are more than three or four hours in a day, when we each don't know where the other is.

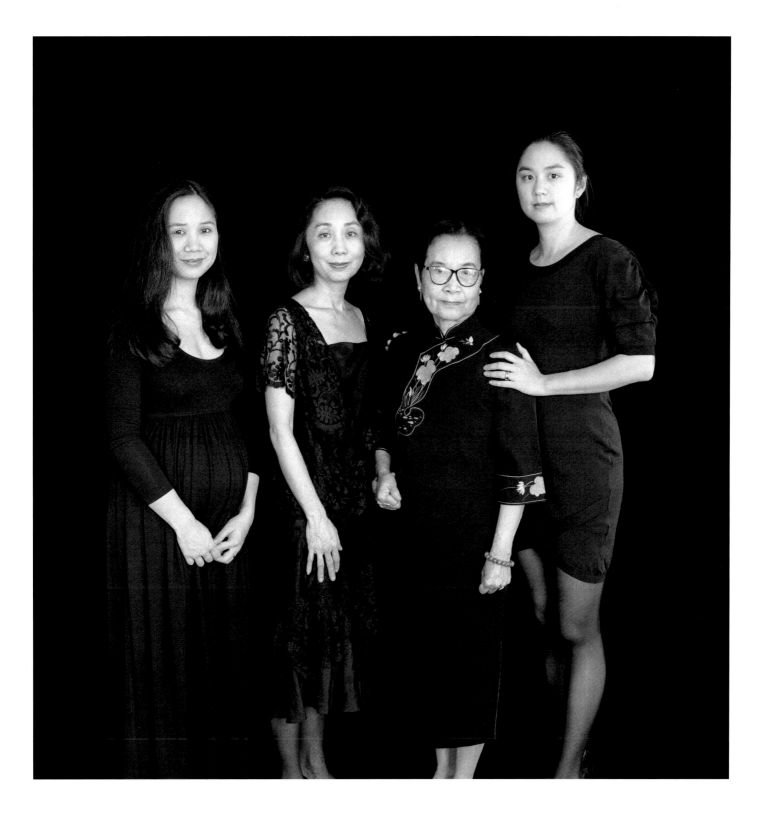

Santana Martinez
Great-grandmother potter
86

I am a potter and my grandmother was a potter, too. We used to go out and gather the clay with her on the hill right near here. It was just women who made pottery, but the men helped with the decorating, and with gathering the wood and the firing. I was always together with my mother-in-law Maria and Aunt Clara and my daughter, making pottery.

Kathy Sanchez
Mother cultural educator and potter
46

I was born and raised in San Ildefonso. My mother had eight children and because there were so many of us, I was raised by my grandmother, my great-grandmother, and my aunt. It was great because I had more people to turn to for advice: you know you have a mother and you know you have a family and you know they love you and they're there, but you also have such an extended family, people moving in and out of the circle of family.

As soon as we were out of sixth grade the educational system encouraged going to Indian boarding school, where we weren't allowed to speak our native language. I went to a Catholic parochial school and that was even harsher because we had our religion telling us that our native ways and spirituality weren't good. When I was first growing up, I tended to doubt my self-worth because the boarding schools were preparing us to acculturate, and making connections with our family or going home was considered to be going backward.

To be a native person in today's society is to live two lives in two different worlds with two different systems and cultural values. However, there's only one of me, so I'm living two hundred percent who I am. In the traditional sense, my grandmother and Corinne and my aunt and I all make our livelihood through pottery. In the other sense, in order to make ends meet and to be a viable citizen of the United States, we also have other careers. I'm a cultural educator, giving lectures and workshops on what it means to have a native perspective in today's world.

In my family, Santana and Maria Martinez would make the pots, and Clara was the best polisher. The women used to make the pots and the men were farmers. After the war, with tourism, the men started helping the women with the pottery. Then men started doing pottery full time and pretty soon more of the traditional way of living fell to the wayside and people started to push pottery for cash income. It was still a family communal process, but the outside market wanted signatures and ownership so the pots would have more value. That was destructive, it caused competition between the women who worked on the pots.

We're reclaiming our culture and tradition and the pendulum is starting to swing toward being closer to nature and taking care of the earth and environment. We're trying to go back into traditions for the survival of everybody on this Earth. My grandparents and my great-aunt can help us; they can still share with us the traditional ways of medicine, language, dances, healing, and community. From my grandmother we learned a sense of universal spirituality where you're thankful that the sun came out to bless you and that you've got a day to live your life, and you pace yourself according to what human interactions come about.

Corrine Sanchez
Daughter environmental cultural consultant and potter
25

In our pueblo, women don't have the right to vote and don't have a say in a lot of issues, and yet they're the bearers of the future. Women doubt themselves, and there's a lot of alcohol and loss of culture and meaning as a result. That's something that needs to be worked out.

My mother has great knowledge about a lot of things that I look to for guidance, like understanding the relationships between pottery-making and your spirituality and yourself. We usually make pots once or twice a month. It's a communal process, so we'll sit down and work on them together—my great-grandmother and my Aunt Clara, who's too fragile to polish anymore, so she doesn't really sit down, my mom, and my cousin Myra or my Aunt Evelyn will come over and we'll sit down and work on pottery or get together and work on things together.

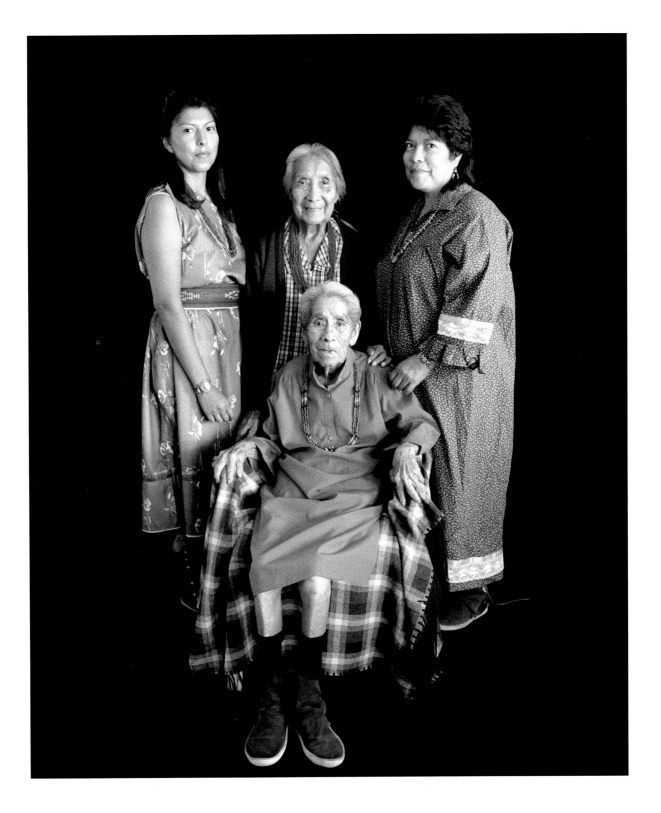

Margaret Waters

Grandmother amateur painter
80

My mother died in the flu epidemic when I was two years old, and I was taken care of by my mother's stepmother for two years. She was trying to make up for having been mean to my mother, and she was very good to me. I had two wonderful years with my step-grandmother. Then my father came home from the First World War and married someone to take care of the two children. He never really loved her so it was pretty hard.

Alice was a very peppy child. The teen years were the most difficult, she would be off on some escapade or having a huge party somewhere and it would be pretty scary. Between her junior and senior years of college, she took a year off and hitchhiked around France. That's where she got her interest in food. She saw chefs out in the country picking vegetables right out of the gardens, and then when customers would finish their dinner, everybody would clap for the chef. She thought that was pretty interesting, and when she came back she started cooking for her friends.

Alice Waters

Mother restaurateur
52

I had three sisters and I felt my mother had a very hard job. She tried to be there for all of us. I didn't have a really close relationship with her that I remember, but she was always there to comfort me when I had dreams in the middle of the night and when I didn't feel well. She was concerned about good health and about what we ate; it was very unusual in those days. In the morning I would have a nice big bacon sandwich with lots of butter on it. That was what was considered good for kids to have in the fifties. The good old days. And whole-grain brown bread, and wheat germ sprinkled on things, and I had to take my vitamins every day. We never had cookies or sweets around the house. We all went out and bought candy, but it was something that she really impressed upon me.

I remember her canning applesauce made from our trees in the garden. My parents had a victory garden during the Second World War. I remember those smells, like rhubarb cooking. When I cried, my mother always put me down under the apple tree, and the blossoms would fall on the baby carriage. I've always had a thing about apple trees.

Fanny's an only child. I'm involved in her life a lot and I like it. She's always sort of felt like a pal, a friend, to me. It's important being close, but not too close, allowing her room for herself. I guess I wanted more of my mom when I was little, and I think Fanny might want less. Fanny is involved in a lot of the work that I do at the restaurant. She's been working in the kitchen. When she was little, I wrote a book about her experiences in the restaurant, and now she actually had a job this summer, so she understands some things about me, too. Balancing work and home was always difficult, but luckily I could work at home or have flexible hours so that I could dash back and have lunch with her. She could come over to the restaurant to have dinner with us. I think it's really important that parents and kids have meals together. You have to make time.

Fanny Singer

Daughter student
13

I've learned about cooking and food from my mom, and everything that she tries to teach other people. She gives speeches, and she's always said to me that if she can't manage to give one, she wants me to do it instead, because I know everything that she would have said. She's taught me about what's happening in the world, how other people live their lives. She's always telling me that I need to have bigger interests than just what's happening to me. A lot of what she talks to me about has to do with the environment because that's what's she's really concerned about. Ever since I was really little I wanted to do something to help the environment. I've always written letters to our governor and our president about what's happening

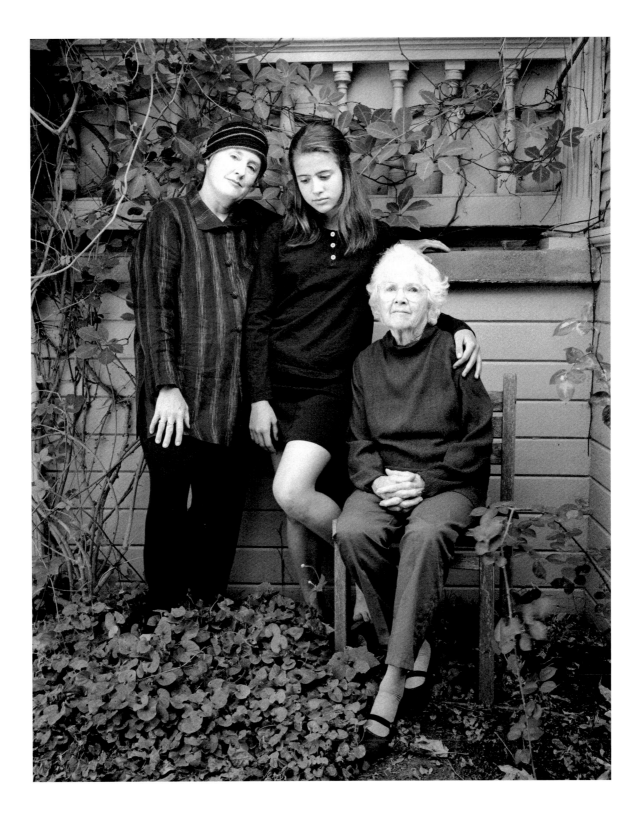

Margaret Cook
Grandmother translator
83

When I was a child, children in our group did not have relationships with their mothers. It was considered déclassé to take care of your own child and it was a matter of prestige to have employees do that. I was trained, like the other children I knew, to stand up when my mother entered the room, regardless of what I was doing, and always to let her precede me through doorways. My mother was lively and pleasure loving. She had an artistic flair and she was able to paint and sculpt, but she did it only as an occasional activity.

When I got older, I did not have more of a relationship with her than I had had as a child. It was a Victorian upbringing and there's been more change in the last twenty-five years than in the more than one hundred years before that. The wheel has more or less come full circle now, because women have jobs as well as families and this farming out of the children to hirelings has resumed.

I tried very hard to let my daughter grow up naturally, without unnecessary interference from me. Mariana was very much an observer and not so much a participant, like me. I had a wonderful time when she was little because I started to form her taste by letting her choose her clothes. Watching her taste develop in that way is one of my very happy memories of her childhood. She has wonderful taste in clothes now and in everything else and I like to think I gave her a good start. I miss the fun I used to have shopping with her, now that she is a professional person.

My granddaughter, Emily, is the only offspring I have who looks like me and is like me. She thinks a lot. She was born with a very happy nature and I am happy by nature. I hope she will fulfill her potential and be very happy in her life.

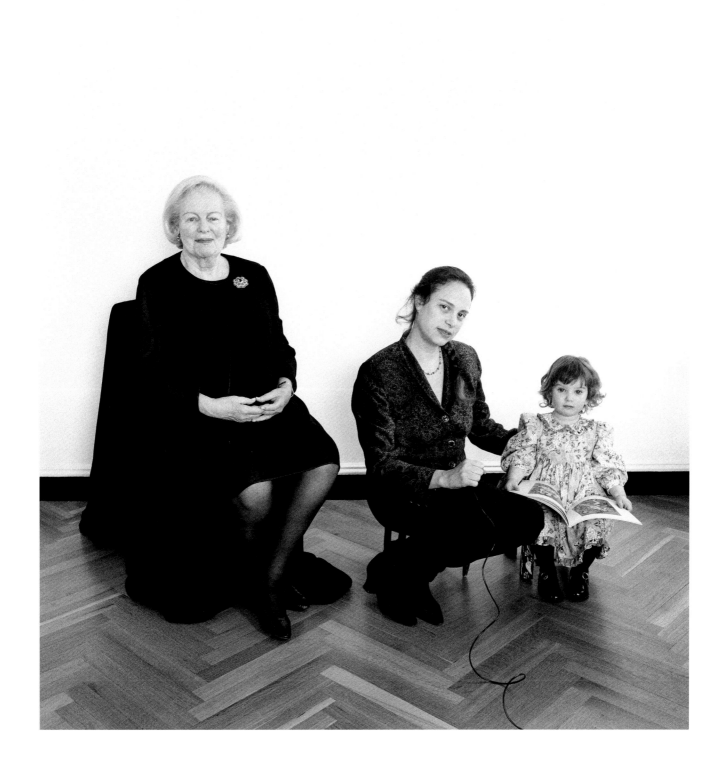